FOR KITH AND KIN The Folk Art Collection at the Art Institute of Chicago

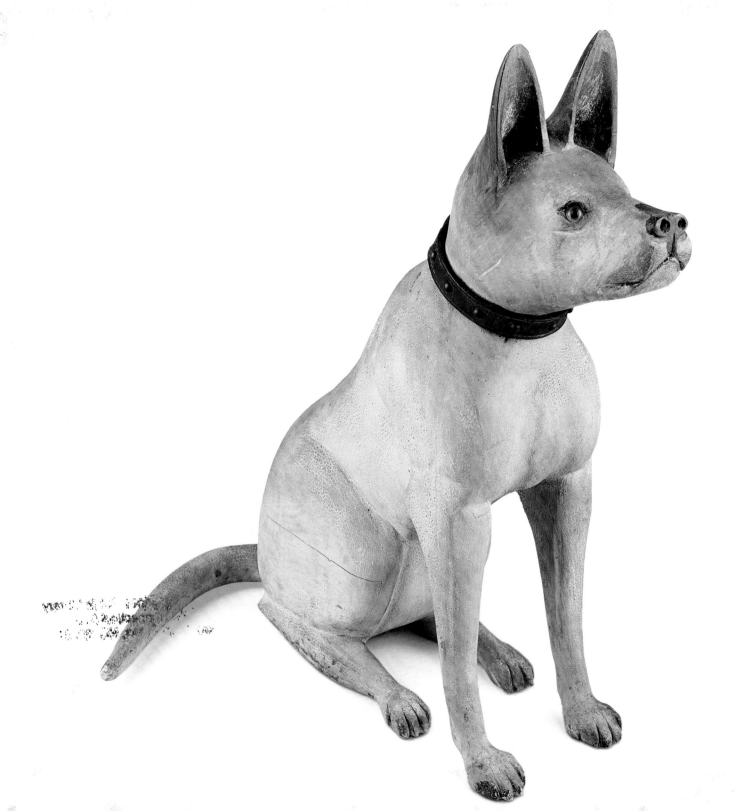

FOR KITH AND KIN

The Folk Art Collection at
the Art Institute of Chicago

Judith A. Barter and Monica Obniski

THE ART INSTITUTE OF CHICAGO

YALE UNIVERSITY PRESS New Haven and London

First edition
Printed in Canada
Library of Congress Control Number: 2011944568
ISBN: 978-0-300-17972-9

Published by
The Art Institute of Chicago
111 South Michigan Avenue
Chicago, Illinois 60603-6404
www.artic.edu

Distributed by
Yale University Press
302 Temple Street
P.O. Box 209040
New Haven, Connecticut 06520-9040
www.yalebooks.com/art

Produced by the Publications Department of the Art Institute of Chicago, Robert V. Sharp, Executive Director

Edited by Susan E. Weidemeyer

Production by Sarah Guernsey and Joseph Mohan

Photography research by Lauren Makholm

Designed and typeset by Glue + Paper Workshop LLC, Chicago, Illinois

Separations by Professional Graphics, Inc., Rockford, Illinois

Printing and binding by Friesens Corporation, Altona, Manitoba, Canada

This book was made using paper and materials certified by the Forest Stewardship Council, which ensures responsible forest management.

Front and back cover: *Doorframe* (cat. 29) (detail), 1840/60.
Back cover: William Bonnell (1804–1865). *J. Ellis Bonham* (cat. 20), March 5, 1825.
Frontispiece: *Bull Terrier*, 1875/1900. Pine; 59.8 x 30.5 x 47 cm (23 ½ x 12 x 18 ½ in.). The Art Institute of Chicago, restricted gift of Charles C. Haffner III, 1983.789.
Page 8: *Female Bust* (cat. 40) (detail), 1800/30.
Page 26: *Rug* (cat. 41) (detail), 1850/1900.

CONTENTS

6 Foreword DOUGLAS DRUICK

7 Acknowledgments JUDITH A. BARTER

9 Friendship, Faith, and Folk Art JUDITH A. BARTER

27 The Collection JUDITH A. BARTER AND MONICA OBNISKI

119 Selected Bibliography

120 Photography Credits

FOREWORD

Folk art has a long history in Chicago. Many of the Art Institute of Chicago's earliest and most significant benefactors—Robert Allerton, Florence Dibell Bartlett, Emily Crane Chadbourne, Frank Wakeley Gunsaulus, Emma B. Hodge, and Elise Tyson Vaughan, among others—collected folk art along with the European paintings, English ceramics, and textiles for which they are best known. Though their interest in folk art has been little documented, it forms a fascinating chapter in the history of the museum.

Until 1986, when Juli and David Grainger, through The Grainger Foundation, endowed a folk art gallery at the Art Institute, American folk art traveled around the building, in and out of storage, or was installed with other collections. The Grainger Foundation's gift assured that folk art would always have a place within the larger context of the Art Institute's American art collection and within the canon of art history in this encyclopedic museum. With the completion of the new Modern Wing in 2009 and the reinstallation of the museum's entire permanent collection, the Foundation endowed an even larger gallery space for folk art. Opened in August 2009, this gallery allows us to display more folk art objects than ever before. The Foundation then complemented that gift with yet another, allowing us to publish *For Kith and Kin: The Folk Art Collection at the Art Institute of Chicago*, the first catalogue of the museum's folk art collection. We are deeply grateful to Juli and David Grainger and The Grainger Foundation for their extraordinarily generous support.

I would like to thank Judith Barter, Field-McCormick Chair and Curator, Department of American Art—whose vision led to the creation of this notable volume—and Monica Obniski, Assistant Curator of American Decorative Arts, for their excellent research in bringing this unpublished collection to the fore. They were supported in their efforts by the staff of the museum, whose enthusiasm for art of all types has made the Art Institute one of the world's great museums.

Douglas Druick
PRESIDENT AND ELOISE W. MARTIN DIRECTOR
THE ART INSTITUTE OF CHICAGO

ACKNOWLEDGMENTS

For Kith and Kin: The Folk Art Collection at the Art Institute of Chicago was made possible by a grant from The Grainger Foundation. Juli and David Grainger have had an abiding interest in folk art for many years, and their generosity has made possible the installation of the Art Institute's collection in its own endowed gallery and the purchase of additional folk art objects to enrich that collection. This volume celebrates the excitement of exploring our nation's past through the vision of America's vernacular artists, craftsmen, and traditions, presenting the varied types of objects made by America's homegrown talent for their kith and kin.

At the Art Institute, I am indebted to my coauthor, Monica Obniski, for her excellent research and writing of many entries. Sarah Kelly, Denise Mahoney, and Ellen Roberts in the Department of American Art offered their enthusiastic support for the project. Departmental interns Samantha Alfrey and Jack Whalen provided research help. I am also grateful to Odile Joassin of the Department of Textiles, who wrote several entries for this volume, and to textile conservators Lauren Chang and Isaac Facio, who provided important additional assistance. Thanks to Christopher Shepherd of the Department of American Art for his tireless installation of objects and for managing the new photography required for this publication. In the Imaging Department, Robert Hashimoto took the brilliant photographs that appear on the following pages, and Nancy Behall, Clare Britt, and Jennifer Stec coordinated the photography. In the Department of Prints and Drawings, Harriet Stratis, chief paper conservator; Kimberly Nichols, associate paper conservator; and Dawn Jaros, Kress Fellow in Conservation, provided important expertise and treatment for some of the objects in this volume. Likewise, Painting Conservator Faye Wrubel treated many of the painted objects. In the department of African Art and Indian Art of the Americas, Elizabeth Pope, Ray Ramirez, and Richard Townsend provided important help and research for a number of objects. The Publications Department, under the direction of Robert Sharp, handled the editing and production of this book. Susan Weidemeyer thoughtfully edited the manuscript, while Sarah Guernsey, Lauren Makholm, and Joseph Mohan coordinated the images and production. This publication owes its eye-catching design to Joan Sommers of Glue + Paper Workshop, Chicago. Finally, I would like to thank James Cuno, former Art Institute director, and current President and Eloise W. Martin Director Douglas Druick for their great support of this project.

While the introduction to this volume chronicles the early collecting of folk art in Chicago, many more recent patrons associated with the Department of American Art have made gifts to benefit this collection. They include the late Harold Allen, the Antiquarian Society, the late Quinn Delaney, Wesley M. Dixon Jr., Marshall and Jamee Field, Juli and David Grainger, Charles Haffner III, Jan Pavlovic, Esther Sparks Sprague, Mrs. Herbert Vance, Carol W. Wardlaw, and Jill Burnside Zeno. It is our hope that all who enjoy American history, culture, and the vernacular vision will enjoy seeing these objects—many of which are presented here for the first time.

Judith A. Barter
FIELD-McCORMICK CHAIR AND CURATOR, DEPARTMENT OF AMERICAN ART
THE ART INSTITUTE OF CHICAGO

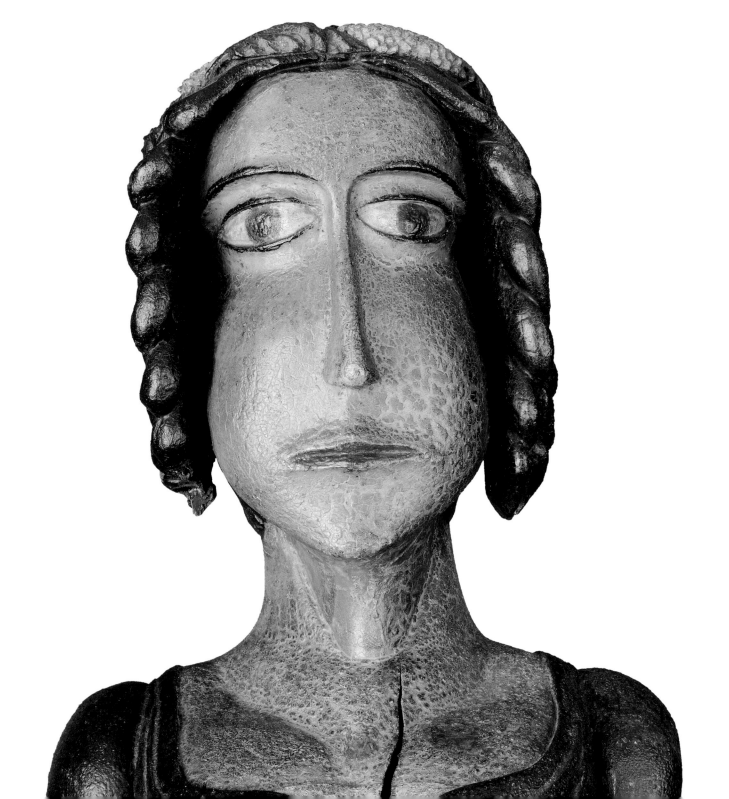

JUDITH A. BARTER

FRIENDSHIP, FAITH, AND FOLK ART

Usually from vernacular and rural traditions, folk art at its best implies work produced by those with a singular vision, often highly skilled craftsmen, perhaps unsophisticated by academic standards, but with a sense of composition, decoration, and design that is superb. The early history of folk art at the Art Institute of Chicago is a rich one, enhanced by the generosity and vision of many inspiring collectors.

American Folk Art in Chicago

EMMA B. HODGE AND FRANK WAKELEY GUNSAULUS

Emma B. Hodge was first known in Chicago for her superlative, professionally trained contralto and her contributions to the Plymouth Congregational Church and the choral programs of the city. Born in Milwaukee, she met her husband, Walter Hodge, an English immigrant working in a dry-goods store, while singing in a Swedish and Norwegian choral group, the Freja Society. The couple married in 1879 and had three children by 1885. The 1900 census records list Mrs. Hodge, by then a widow, living with her sister, Jene Bell, their widowed mother, and a servant. By 1905 the family lived on Ellis Avenue, in a fashionable neighborhood on the city's South Side.

How Hodge gained the financial means to become an important collector of ceramics, books, samplers, quilts, and antique valentines is an unsolved mystery. She began to collect pottery in the 1890s with the help of her close friend Frank Wakeley Gunsaulus, who was the pastor at Plymouth Church after 1887. In 1899 he formed an independent church, the Central Church, which held services at the Auditorium Building on Michigan Avenue. Both Hodge and Gunsaulus were patrons of the Art Institute and two of the earliest and most important folk art collectors (fig. 1).

Initially, Hodge and her sister, Jene Bell, put together a collection of over one thousand pieces of American and English pottery and porcelain in memory of their mother, Amelia Blanxius,

whose family had come from Sweden to join the large community of Swedes in Chicago. They gave that collection—ranging from old Worcester soft-paste porcelain, Chelsea figurines, Staffordshire creamware, and Whieldon-Wedgwood pottery, to early English slipware (fig. 2) and New England red earthenware (fig. 3)—to the Art Institute in 1912–15. Hodge's interest in American history is reflected in some of the transfer-printed English pottery made for the American market that she collected, such as a Liverpool jug depicting the new states of the young republic (fig. 4).

Hodge continued to donate porcelain and pottery to the museum in the following years, but her interest also turned to

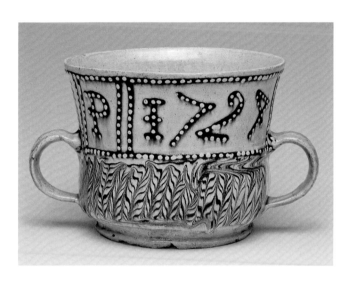

textiles. In 1915 the museum borrowed samplers from her collection to show at the *13th Annual Exhibition of Industrial Arts*, which was ironically titled given that it was a show about the rich history of textiles and handicraft. The term *industrial* was at the time the equivalent of what we today might call "useful" arts, as industry included human labor. Alongside Hodge's samplers were weavings from the looms of the Herter Brothers and embroidery by Hungarian peasant workers.

Interest in textiles at the Art Institute was high. From the founding of the Decorative Art Society in 1879, with the help of textile artist Candace Wheeler, both the Antiquarian Society and

Fig. 4
Jug, 1796/1803. Liverpool, England. Earthenware (creamware) with transfer decoration; 16.8 x 18.1 cm (6⅝ x 7⅛ in.). The Art Institute of Chicago, Amelia Blanxius Collection, gift of Emma B. Hodge and Jene E. Bell, 1912.29.

Mr. and Mrs. Martin A. Ryerson began collecting textiles. At the height of the Arts and Crafts movement in Chicago, there was a growing recognition of the importance of historic textiles and the promotion and preservation of immigrant handicrafts at institutions such as Hull House and the Art Institute.

Hodge's textile collecting had the same motivation as her pottery collecting—her love of the eighteenth and early nineteenth centuries and her association of that period with the patriotism of the early republic. The Colonial Revival was so strong a motivation in her collecting that one of Hodge's gifts to the Art Institute, an album quilt of 1862 (fig. 5), was sentimentally described early in the twentieth century not in terms of its beauty, but through the romanticized story of its ownership by an Ohio

itinerant preacher, who, as an evangelist, converted hundreds on the frontier. No doubt Hodge herself embellished the provenance of the quilt, saying that it belonged to a "circuit rider" and that quilts represented "the story of American women from Jamestown and Plymouth down; the story of their thoughts and hopes and dreams, as well as of the skill of their fingers."[1] Literature about the quilt described the preacher on his horse holding a Bible. Yet there is no record that the supposed owner of the quilt was a circuit rider or that such ministries were common in 1862. There is also no record of how Hodge obtained the quilt. However, the associations of an object were as important as the object itself for Colonial Revival collectors.[2]

An interest in the Colonial Revival and craftsmanship was common in collecting circles during the early twentieth century. Indeed, Hodge's passion for quilts ran parallel to her friend Gunsaulus's love of weavings. He donated over thirty weavings to the Art Institute in 1911 (fig. 6), and by 1922, the date of his last gift, his collection of coverlets—beautiful examples of the use of looms during the Industrial Revolution—numbered well over sixty. Gunsaulus helped to found the Armour Institute of Technology with Philip Armour in 1893 and served for twenty-seven years as its first president. He wrote that education must link head, hand, and heart and made providing vocational training for young men his mission.[3] This linking of craft with machine certainly informed his collecting of American woven coverlets.

Fig. 5
Bedcover (The Circuit Rider's Quilt), c. 1862.
Miami, Ohio. Cotton, pieced plain weave;
quilted with cotton yarn; appliquéd and
reverse-appliquéd with cotton and wool, plain
weaves; some roller-printed; embroidered
with cotton and gilt-metal-strip-wrapped
cotton in chain stitches; laidwork and
couching; signatures in sepia ink; edged with
cotton 2:2 twill weave; backed with cotton,
plain weave; 215 x 241.5 cm (85¾ x 95 in.).
The Art Institute of Chicago, gift of Emma B.
Hodge, 1919.535.

Fig. 6
Coverlet, 1853. Chesterville, Ohio. Cotton
and wool, plain weave with supplementary
patterning wefts bound by main warps
in plain interlacings with main warp and
supplementary patterning weft fringe; 250.8 x
209 cm (98⅞ x 82¼ in.). The Art Institute of
Chicago, gift of Frank W. Gunsaulus, 1911.225.

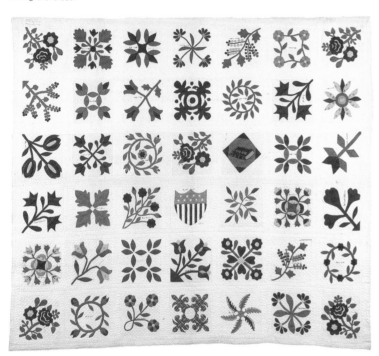

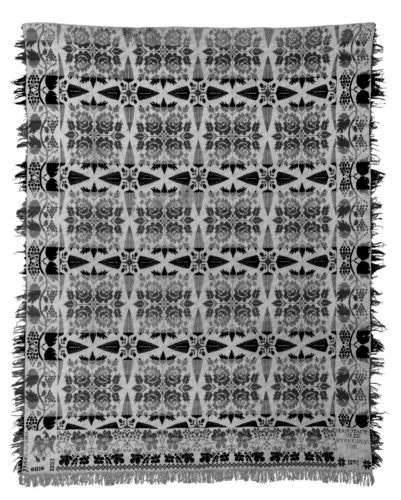

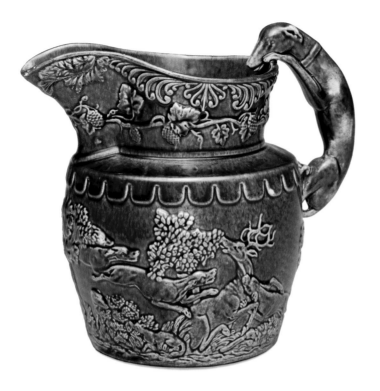

Fig. 7
Hound-Handled Pitcher, c. 1850. Earthenware; 20.3 x 22.2 cm (8 x 8¾ in.). The Art Institute of Chicago, Amelia Blanxius Collection, gift of Mrs. Emma B. Hodge and Mrs. Jene E. Bell, 1912.284.

and attended auctions. She surrounded herself with artifacts (see fig. 7) in her room in her daughter's house at 618 Deming. There, amid soft chrome-colored wallpaper with muted gray and brown medallions of Paul Revere's ride, John Hancock's house, the Boston Tea Party, Independence Hall in Philadelphia, the Liberty Bell draped with the American Flag, Betsy Ross's house, and the fifes and drums of the "Spirit of Seventy Six," she wrote "Chats on Collecting" for her family. She also gave to other institutions along with the Art Institute, including the Philadelphia and Cleveland art museums, and generously advised collectors in her circle.[4]

WILLIAM H. AND ALICE TRAINER MINER

During the summer, both Gunsaulus and Hodge visited their Chicago friends William H. and Alice Trainer Miner (fig. 8). William, born in Wisconsin, moved as a child to Chazy, New York, a few miles from the Canadian border. In the early 1880s, he made his way west again to work with the railroads centered in Chicago. He patented more than one hundred inventions to improve refrigerated railway cars and made his fortune in his new city. By 1903 the Miners moved back to his childhood farm in Chazy. In six years, the family built over three hundred buildings on the old homestead, now called Heart's Delight, and employed over eight hundred workers in a modern megafarm that grew produce for New York's finest restaurants (and Chicago's Palmer House); contained fish hatcheries and gristmills; and raised

Hodge also continued to collect textiles but, unlike Gunsaulus, favored the handwork of pieced quilts and schoolgirl samplers. She donated twenty-eight quilts made between the 1820s and 1850s to the Art Institute in 1919, and her collection—featuring the "Red Rose Wreath" and "Cherry Trees and Robins" (cat. 18) quilts—was put on indefinite display in the fall of 1922.

These early folk art collectors did not confine themselves to Chicago sources. Near the end of her life, Hodge wrote that collecting was a seasonal activity and that warm spring weather increased her "fever" for travel and the passion of the hunt. She purchased porcelain from the Duveen Brothers in New York

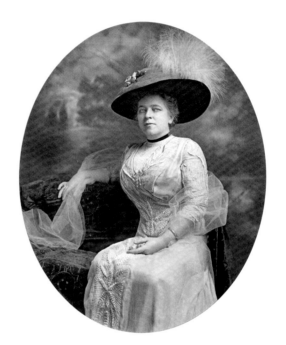

purebred horses, Guernsey and Durham cattle, Dorset sheep, and Yorkshire and Chester white swine. By damming local rivers, the Miners brought electricity to the residents of their rural community by 1908.[5]

The guest books of Heart's Delight show that Alice's Chicago collecting friends Hodge and Bessie Bennett (the first curator of decorative arts at the Art Institute) visited in January 1915 after a successful collecting foray:

While the snow was softly falling
And the logs were burning bright
Three china collectors
At the farm of Heart's Delight
Installed both jugs and platters
In a case all painted white.
These ladies hunted far and wide
Ransacked all the country side
From deerpark unto crossing Lake Champlain
And the treasures they collected
Are now to be inspected
By friends who happen in from off the train.[6]

The following year, Hodge wrote a catalogue of the Miners' collection and donated a piece of Lincoln presidential china to her friend from her own collection.

The Miners' connections to Chicago remained strong. During that same year, Gunsaulus asked William to fund an addition to the Art Institute. He donated the necessary fifty thousand dollars (around one million dollars today) but insisted the wing be named for Gunsaulus instead of himself.[7] During the summers, Hodge visited the Miner farm with Gunsaulus and his daughter, Helen, who was the curator of the Buckingham Collection of Japanese prints at the Art Institute. Both Gunsaulus and Hodge encouraged the Miners to collect Japanese prints during the 1920s.

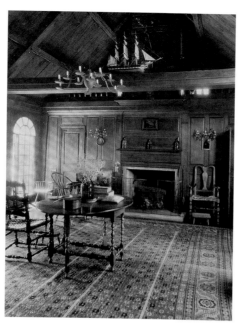

For these friends and collectors, the patriotism and enthusiasm of the Colonial Revival had given way to the Arts and Crafts movement's love of all things handmade and preindustrial. Gunsaulus continued to collect coverlets (he and his wife founded the Colonial Coverlet Guild of America in 1924 to support weaving projects) but also now amassed a collection of rare books, manuscripts, and Japanese prints. Hodge widened her collecting interests—focusing on nineteenth-century valentines, glass, children's books (including Kate Greenaway illustration proofs), Rowlandson prints, toys, dolls, and Far Eastern textiles in addition to ceramics and American textiles—until her death in 1928.

ELIZABETH TYSON VAUGHAN AND EMILY DAVIS TYSON

Art Institute connections with Boston collectors also helped to develop interest in folk art. Elizabeth (Elise) Tyson Vaughan, married to a prominent Boston attorney, kept homes in Sherburn, Massachusetts, and South Berwick, Maine, and was the sister of Art Institute trustee Russell Tyson. She was deeply involved with the Society for the Preservation of New England Antiquities (today called Historic New England). Vaughan, like Hodge and Gunsaulus, collected early American objects, furniture, textiles, silhouettes, toys, and other folk art. After her death in 1949, she left Hamilton House (fig. 9)—her home in Maine—to the Society for the Preservation of New England Antiquities, and much of her collection went to what is today the Peabody Essex Museum in Salem, Massachusetts. But her brother, Russell, and Curator of Decorative Arts Meyric Rogers also selected items for the Art Institute from her collection. Among the more outstanding pieces chosen were an exceptional early Windsor armchair from Philadelphia (fig. 10), Susan Torrey Merritt's watercolor *Antislavery Picnic at Weymouth Landing, Massachusetts* (c. 1853) (cat. 30), and Wilhelm Schimmel's late-nineteenth-century carved *Eagle* (cat. 50). The Elizabeth Vaughan Bequest of American Folk Art went on view in the museum in 1953 and was the first permanent exhibition of folk art in Chicago.[8]

Vaughan and her stepmother, Emily Davis Tyson, discovered Hamilton House through their friend Sarah Orne Jewett, a Maine novelist who wrote about the then-derelict home in her 1881 *Atlantic Monthly* story "River Driftwood," saying that it provided "a quiet place that the destroying left hand of progress had failed to touch."[9] Both widowed young, Vaughan and Tyson sought a restful

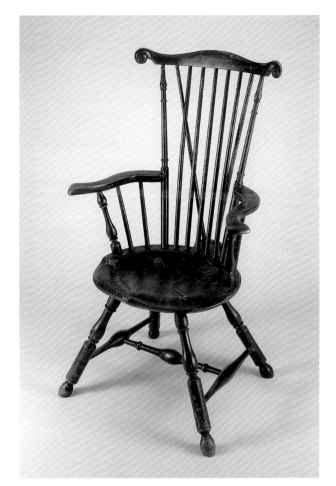

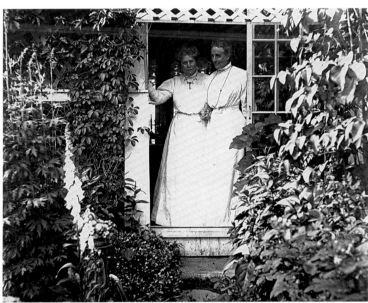

Fig. 10
Fan-Backed Windsor Chair, 1760/70.
Philadelphia, Pennsylvania. Tulip, maple,
hickory, and oak; 102.4 x 49.1 x 44.5 cm (40 ⅜
x 19 ⅜ x 17 ½ in.). The Art Institute of Chicago,
bequest of Elizabeth R. Vaughan, 1950.1713.

Fig. 11
Elise Tyson Vaughan. Emily Tyson and Sarah
Orne Jewett, 1905. Historic New England.

retreat from society. They became famous for their gardens, and, ironically, though she sought to live in the past, Vaughan was a good photographer who romantically recorded the interiors and gardens of the house and captured her stepmother and Jewett standing in its doorway (fig. 11). Like Jewett, who honored a Maine long past in novels like *Country of the Pointed Firs* (1896), Tyson and Vaughan were collectors who sought to re-create a life based in both the Colonial Revival and Arts and Crafts. With the

passing of the first generation of folk art collectors, so influenced by the aesthetics of these movements, the genre became the purview of modernists.

EMILY CRANE CHADBOURNE

Emily Crane Chadbourne was the daughter of Richard Crane, an overbearing plumbing manufacturer who did not believe in higher education for girls. His daughter married young and

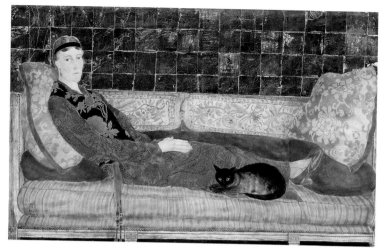

Fig. 12
Tsugouharu Foujita (Japanese, 1886–1968).
Portrait of Emily Crane Chadbourne, 1922.
Tempera and silver leaf on canvas; 89.5 ×
146.1 cm (35¼ × 57½ in.). The Art Institute
of Chicago, gift of Emily Crane Chadbourne,
1952.997.

unhappily in the 1890s and by 1905 had divorced and fled to Europe. In Paris she joined the circle of Gertrude Stein and formed a partnership with Stein's school friend Ellen LaMotte, a Johns Hopkins–trained nurse who wisely managed Chadbourne's inheritance. Chadbourne and LaMotte knew the American expatriate women living in Paris and became friends with Boston's Sarah Choate Sears, a collector of French and American Impressionist paintings. Chadbourne was also a friend of the Boston collector Isabella Stewart Gardner and was once embarrassingly stopped at customs attempting to smuggle objects of vertu into the country as household effects for Gardner.[10]

At her London apartment, Chadbourne entertained members of the Bloomsbury Group, including critic Roger Fry, painter Augustus John, and collector Lady Ottoline Morrell. In Paris she led these same friends to dealers and collectors, and lent works by Paul Gauguin and Henri Matisse to Fry's first Post-Impressionist exhibition.[11] She chose the Parisian modernist Tsugouharu Foujita to paint her portrait—perhaps a tongue-in-cheek homage to Édouard Manet's *Olympia*, complete with a black cat (fig. 12). Despite her interest in modern art, Chadbourne also collected textiles, furniture, carpets, glass, porcelain, and folk art, storing her collections in warehouses in London and Paris.

Chadbourne and LaMotte returned to the United States in 1924, living in Washington, D.C., and the Hudson River Valley at Stone Ridge, New York. Over the years, Chadbourne gave hundreds of thousands of dollars as well as almost two thousand objects to the Art Institute, including paintings by Gauguin, Matisse, Henri Rousseau, and James McNeill Whistler; hooked rugs; wallpaper panels; coverlets; and printed handkerchiefs. One can see Chadbourne's sophisticated taste in both her contemporary paintings and her hooked rugs (fig. 13), in which color, pattern, and abstraction dominate. Indeed, Chadbourne, like other collectors in the 1920s and 1930s, recognized the affinity between the abstract, simple lines of modern and folk art objects.

FOLK ART FROM MAINE: ROBERT LAURENT, THE HALPERTS, AND HOLGER CAHILL

During the 1920s, American painters Marsden Hartley, Bernard Karfiol, Yasuo Kuniyoshi, Robert Laurent, Niles Spencer, and William Zorach collected folk art. Many were associated with the new Ogunquit School of Painting and Sculpture in Maine, founded by folk art collector Hamilton Easter Field in 1913. These modernists—drawn to the abstract nature of primitive paintings and crafts—had easy access to decoys, weather vanes, hooked rugs, quilts and coverlets, and paintings by early itinerant

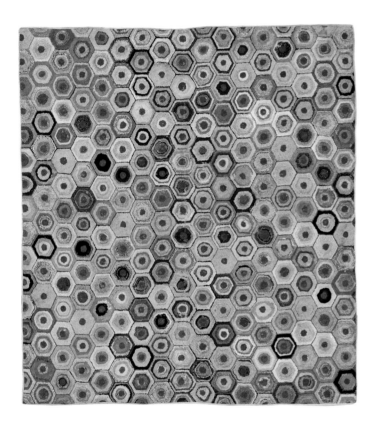

limners, which were still available in local shops and homes.
Their enthusiasm was shared by other modernists, including Elie
Nadelman and Charles Sheeler. Sheeler documented his collec-
tions in beautiful drawings and photographs of stoves, rag rugs,
and Shaker chairs. Nadelman and his wife opened a museum of
folk art in Riverdale-on-Hudson, New York, in 1924.

In New York City, the Whitney Studio Club showed *Early
American Art*, organized by Henry Schnackenberg, in 1924.
This exhibition stimulated interest in folk art collecting and
the development of other exhibitions in the city, where dealer
Valentine Dudensing mounted the show *Early American Portraits and
Landscapes*. Most of the works in this exhibition were borrowed
from Ogunquit artist Laurent, who inherited the entire estate of
Field in 1925. Laurent rented a summer cottage to the painter
Samuel Halpert, whose wife, Edith, owned a contemporary-art
gallery in New York City. In the summer of 1926, the Halperts
brought their friend Holger Cahill, then a curator at the Newark
Museum, to Maine to look for acquisitions of modern art.[12]
They were stunned by the folk art in Laurent's home and, drawn
to the affinity between such "primitive" works and modern-
ist art, the two became enthusiastic collectors and promoters
of American folk art. The linear qualities; pure, often primary
colors; simplified forms; and lack of perspective made these
early-nineteenth-century works feel contemporary. Edith Halpert
began showing American folk art at the Downtown Gallery in

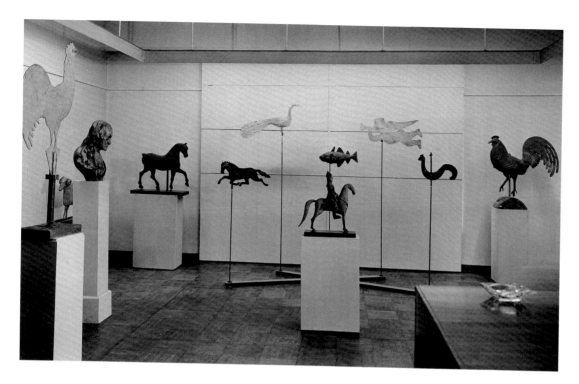

Fig. 14
Folk art exhibition at the Downtown Gallery, 1950/70. Downtown Gallery Records, Archives of American Art, Smithsonian Institution.

1929 and by 1931 had opened the American Folk Art Gallery, writing in *Art Digest* that she had chosen her stock not for its antiquity or historical associations but because of its relationship to the aesthetics of contemporary art.[13]

Yet others relished all the associations of "folk." The Harvard Society for Contemporary Art held an exhibition of folk art in 1930 not only because of its abstracted nature, but also because the subject matter had associations of "springing from the common man."[14] During the Depression, the emphasis on democratic ideals and the dignity of the common, working citizen took on powerful meaning. The art and literature of New Deal artists paid by the government glorified the lives of ordinary people and encouraged a new American culture. While primarily concerned with providing relief to unemployed writers and artists, the government's art-patronage programs also sought to restore national confidence and unity. Many of the federal projects were focused on recording and preserving American history and culture. Photographers, printmakers, painters, playwrights, filmmakers, and others captured the artifacts of the country's history.[15] This association of folk art with both modernism and patriotism was reflected in the Museum of Modern Art's 1932 exhibition *American Folk Art: The Art of the Common Man in America, 1750–1900.*

Shortly after the close of the Harvard exhibition, Cahill opened a folk art exhibition at the Newark Museum entitled *American Primitives;* like Edith Halpert's earlier show, it emphasized the aesthetic rather than historical basis of the works included. Parts of the exhibition traveled to Chicago and were shown at the Renaissance Society of the University of Chicago. Paintings in the Chicago venue were lent by Alexander Brook, Kuniyoshi, Laurent, Mrs. Nadelman, and Zorach. The Renaissance Society, a venue

for contemporary-art exhibitions, seemed an odd choice for an exhibition of "primitive" paintings accompanied by a display of schoolgirl samplers from the collection of Dr. James W. Walker. But here again the catalogue introduction made the case that these were works by amateurs and showed "certain elements in common with Oriental art; the work of children; and the naivete to which 'modern' artists have aspired—as may be seen in the work of the renowned modern master, [Henri] Rousseau."[16] The flattened perspective, bright colors, and bold design of these works were seen as modern, inspired, and showing natural, untutored talent.

In 1931 Cahill organized an exhibition of American folk sculpture that included weather vanes, metalwork, and pottery. He borrowed extensively from the collection of Abby Aldrich Rockefeller, who had become a client of Edith Halpert by 1928. Halpert, who had opened her contemporary-art gallery in 1926, was showing three-dimensional primitive objects alongside works by her stable of artists, including Kuniyoshi, Sheeler, and Zorach (fig. 14). Mrs. Rockefeller's enormous collection of folk art, assembled during the following decade, eventually became the basis for the Abby Aldrich Rockefeller Folk Art collection today housed at Colonial Williamsburg, whose restoration began in the 1920s with Rockefeller funding.

Cahill would go on to lead the *Index of American Design* project under the Federal Art Project of the Works Progress Administration during the Depression. The largest of the New Deal art programs, it amassed more than 17,000 watercolor illustrations of early American and folk art objects between 1935 and 1941, and provided employment for hundreds of artists. In 1937 the project sent a traveling exhibition of watercolors to Chicago. Shown in the School of the Art Institute lobby, the display included beautiful drawings of Shaker furniture, Pennsylvania German pottery, textiles, mourning pendants, cotton prints, lamps, jugs, dresses, and weather vanes. Two years later, Marshall Field and Company department store mounted another exhibition of watercolors from the *Index*'s thousands of records.

ROBERT ALLERTON

During the same period, the Art Institute benefited from the collecting of Robert Allerton (fig. 15), the privileged son of Samuel Waters Allerton, a founder of the city's stockyards and the First National Bank of Chicago. Allerton grew up in the city's exclusive Prairie Avenue neighborhood, attended St. Paul's School, toured Europe, and studied art with his Chicago boyhood friend Frederic Clay Bartlett Jr., who was a muralist and collector.[17] After his return to the United States, he left Chicago society and became a farmer in downstate Illinois. Because he was deaf, Allerton was more comfortable in nature, often alone, and with objects, though in 1906 the *Chicago Tribune* considered him the richest and most eligible bachelor in Chicago.[18] Over the years, Allerton bought hundreds of gifts for the Art Institute, including its first sculptures by Auguste Rodin and its first work by Pablo Picasso. Gifts from the 1920s onward included an extraordinary

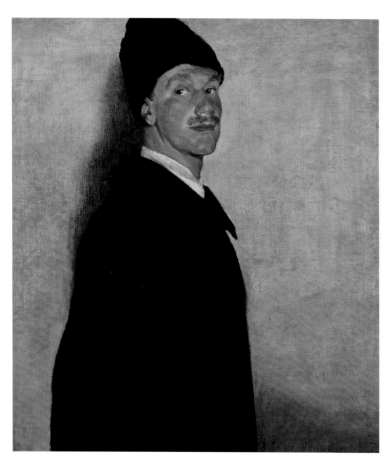

costume collection, contemporary textiles, historic wallpaper, Chinese ivories, early German glazed stoneware, and frakturs. By the time Allerton moved to Hawaii, he had given many of his early American objects to the Art Institute, including the famous Ammi Phillips portraits of his ancestors Mrs. Reuben Allerton and her son, Cornelius Allerton, looking like upright pillars of the community (cat. 11). He also gave a pair of anonymous portraits of two children of the Hallett family from the 1770s and a pair of portraits attributed to Jonas Holman (cat. 26).

International Folk Art

FLORENCE DIBELL BARTLETT

Allerton's lifelong friend Frederic Clay Bartlett Jr. had two sisters who collected folk art and the art of indigenous peoples. The younger, Florence Dibell Bartlett (fig. 16), the heiress to a large wholesale business in Chicago, collected folk art from around the world. She was part of a class of rich, well-traveled, college-educated single women. Proud of her independence and self-assured about her good taste, she tried to make a difference by eschewing the consumer culture of the 1920s and championing craft and indigenous cultures. Her travels took her to Sweden, and her collection of *bonader*, or wall hangings made by Swedish peasants, was shown at the Art Institute in 1932. Two years later, Bartlett gave the contents of a Swedish peasant cottage, including furniture and textiles, to the museum. Sensitive to pattern,

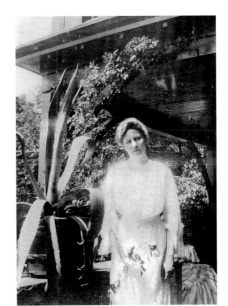

decoration, and craft, she also collected Mexican arts and crafts, showing this collection at the museum in the winter of 1936.

Like others of her time—Mary Austin, Willa Cather, Alice Corbin Henderson, Mable Dodge Luhan, and Georgia O'Keeffe—Bartlett found an independent women's culture that championed new art forms, crafts, and individuality in the Southwest. Both she and her sister, Maie Bartlett Heard, who founded the Heard Museum in Phoenix, were drawn to the Southwest. Florence kept an apartment in Chicago and a winter home—El Mirador—in Alcalde, New Mexico. Believing that "the art of the craftsman is a bond between the peoples of the world," she formed a collection that originally held more than 2,500 objects from thirty-four countries. Thirty years of collecting objects from around the world and enormous financial resources culminated in the creation of the Museum of International Folk Art in Santa Fe in 1952—a gift to the citizens of New Mexico. The death of her sister in 1951 and her brother in 1953 seemed to overwhelm her characteristic optimism, and she took her life in Chicago in 1954. Her legacy was considering her wealth as a trust for the use of others.[19]

EVA AND HERBERT PICKERING LEWIS

During the early twentieth century, an interest in Mexican folk art developed among collectors. Indeed, an appreciation of folk or popular art was part of the celebration of the centenary

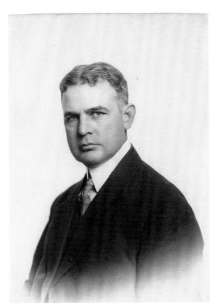

of Mexican independence in 1921. Mexican artists Roberto Montenegro, José Clemente Orozco, Diego Rivera, and David Alfaro Siqueiros all made use of popular art motifs and themes in their work. As the decade progressed, American residents in Mexico joined Mexican artists in collecting folk art. Among them were author Hart Crane, Chicagoans Eva and Herbert Pickering Lewis, Ambassador Dwight Morrow, and silversmith William Spratling.

Born in Chicago in 1876, Lewis (fig. 17) moved to Mexico at age twenty-two to work with his uncle at the National Metal Company at a time when the government of Porfirio Díaz encouraged American business investment. He married fellow Chicagoan Eva Hill in 1901, returned to Mexico, and made a fortune in real-estate speculation. During the Mexican Revolution, Pickering formed a substantial *talavera*-ware collection. When he died suddenly in London in 1922, his young widow and family returned to the United States, and Eva donated the collection to the Art Institute in her husband's memory in 1923.

Lewis acquired more than 180 pieces of sixteenth-, seventeenth-, and eighteenth-century *talavera poblana* earthenware during the late nineteenth and early twentieth centuries, when his family lived in Mexico. Unlike many American expatriates, who collected contemporary Mexican crafts, he was drawn to these historic tin-glazed earthenware basins, jars, plates, and chargers. *Talavera poblana*, named for both the town of its origin in Spain (Talavera de la Reina) and the newer city of Puebla in

Mexico, combines the Hispano-Moresque and Persian influences prevalent in the Mediterranean world. Arriving from Spain in the sixteenth century with the potting wheel and the ability to make tin glazes for earthenware vessels, *talavera* potters established a unique and highly decorative form of earthenware. The designs and shapes of these wares also reflected the ceramic trade from China, the Philippines, Acapulco, Mexico City, and Puebla, to Veracruz and across the Atlantic to Seville.

Truly international, yet considered provincial by Europeans, the potters of Puebla incorporated motifs from all around the world but made their designs a unique part of their craft.[20] As such, they appealed to many collectors active at the turn of the twentieth century, including Emily and Robert de Forest of New York, who were active at the Metropolitan Museum of Art; Edwin Atlee Barber, a curator at the Philadelphia Museum of Art; and Lewis.[21]

Conclusion

Folk art has as many definitions as types of collectors. Few of the early Chicago collectors amassed holdings of folk art only; instead, their folk art collections represented just one facet of their wider interests. Hodge, Gunsaulus, and Vaughan collected folk art for their love of early American history and objects associated with eighteenth- and nineteenth-century craft. Chadbourne and Allerton were drawn to the aesthetic simplicity and design qualities of folk art that were sympathetic to modern art. Florence

Dibell Bartlett and the Lewises were interested in the products and traditions created by the common people of all cultures. What all these early collectors shared was an appreciation and vision of a culture removed from their own. Separated from these objects by place and time, they believed in the importance of saving and treasuring underappreciated traditional expressions of everyday life for future generations.

NOTES

1. Susan Price Miller, "The Circuit Rider's Quilt: Reality and Romance," in *Uncoverings*, ed. Laurel Horton, Research Papers of the American Quilt Study Group 29 (American Quilt Study Group, 2008), p. 26.

2. Ibid., p. 30.

3. Joseph C. Burke, *William H. Miner: The Man and the Myth* (Langdon Street Press, 2009), p. 196.

4. See Emma B. Hodge, "Chats on Collecting" and "The Room," typescripts, 1927. Art Institute of Chicago Archives.

5. Joan and Joseph C. Burke, "William H. Miner: A North Country Legend," Miner Institute, www.whminer.com/history.html.

6. For the Alice T. Miner Collection, see www.whminer.com/history.html.

7. "Notes—The New Wing," *Bulletin of the Art Institute of Chicago* (Oct. 1916), p. 205.

8. Alan R. Sawyer, "American Folk Art," *The Art Institute of Chicago Quarterly* 47, 1 (Feb. 1, 1953), pp. 11–14.

9. Kevin D. Murphy, "Secure from All Intrusion," in *Colonial Revival Maine* (Princeton Architectural Press, 2004), p. 205.

10. "Society Women Evade Customs; Fined $70,000," *Chicago Daily Tribune*, Aug. 19, 1908, p. 1.

11. Margaret Gildea, "Notes Dictated by Margaret Crane-Lillie Gildea about Emily Crane Chadbourne and Other Members of the Crane Family," typescript, Sept. 1, 1978. Art Institute of Chicago Archives. See also Dianne Sachko Macleod, *Enchanted Lives, Enchanted Objects: American Women Collectors and the Making of Culture, 1800–1940* (University of California Press/Getty Foundation, 2008), pp. 194–95.

12. Beatrix Rumford, "Uncommon Art of the Common People: A Review of Trends in the Collecting and Exhibiting of American Folk Art," in *Perspectives on American Folk Art*, ed. Ian M. G. Quimby and Scott T. Swank (Winterthur Museum/Norton, 1980), pp. 19–23.

13. Edith Gregor Halpert, "Folk Art in America Now Has a Gallery of Its Own," *Art Digest* 6, 1 (Oct. 1, 1931), p. 3.

14. Rumford (note 12), p. 25.

15. See Erika Lee Doss, "American Folk Art's 'Distinctive Character': The Index of American Design and New Deal Notions of Cultural Nationalism," in Virginia Tuttle Clayton, Elizabeth Stillinger, and Erika Lee Doss, *Drawing on America's Past: Folk Art, Modernism, and the Index of American Design*, exh. cat. (National Gallery of Art, 2002), p. 67.

16. "Exhibition of American Primitives Collected by the Newark Museum and of Samplers from the Collection of Dr. James W. Walker of Chicago," *The Renaissance Society of the University of Chicago*, exh. pamphlet (1931), n.pag.

17. Bartlett and his second wife, Helen Birch Bartlett, collected some of the Art Institute's most famous Post-Impressionist paintings, including Georges Seurat's *A Sunday on La Grande Jatte—1884*, Vincent van Gogh's *The Bedroom*, and Henri de Toulouse-Lautrec's *At the Moulin Rouge*.

18. At forty-nine years of age, Allerton formed a relationship with a twenty-two-year-old University of Illinois architecture student, John Wyatt Gregg. More than thirty years after they met, in 1960, Allerton took advantage of an unusual twist in the Illinois law and adopted the younger man. This may have been the first legal civil union in the state. The pair traveled through Europe together to study gardens for their Monticello, Illinois, estate. Escaping the antigay political climate of Chicago and the Midwest, Allerton and Gregg bought beachfront property on Kauai, Hawaii, in 1937. In 1946 the couple gifted their Illinois estate to the University of Illinois for use as a conference center and a forest, plant, and wildlife preserve.

19. Ree Mobley, "For All the World to See: Florence Dibell Bartlett's Vision for an Untroubled World," in Laurel Seth and Ree Mobley, *Folk Art Journey: Florence D. Bartlett and the Museum of International Folk Art* (Museum of New Mexico Press, 2003), pp. 36–37.

20. Richard Townsend, "Basin," *Museum Studies* 33, 1 (2007), pp. 84–85.

21. Margaret Connors McQuade, "Talavera Poblana: The Renaissance of a Mexican Ceramic Tradition," *Magazine Antiques* (Dec. 1999), pp. 826–27. Even Chadbourne became interested in forming a collection in 1926 and sought Mrs. Lewis's advice on potential purchases. See correspondence between Bessie Bennett, curator of decorative arts at the Art Institute, and Emily Crane Chadbourne, Dec. 16, 1926, and Feb. 2, 1927. Emily Crane Chadbourne Papers, Art Institute of Chicago Archives.

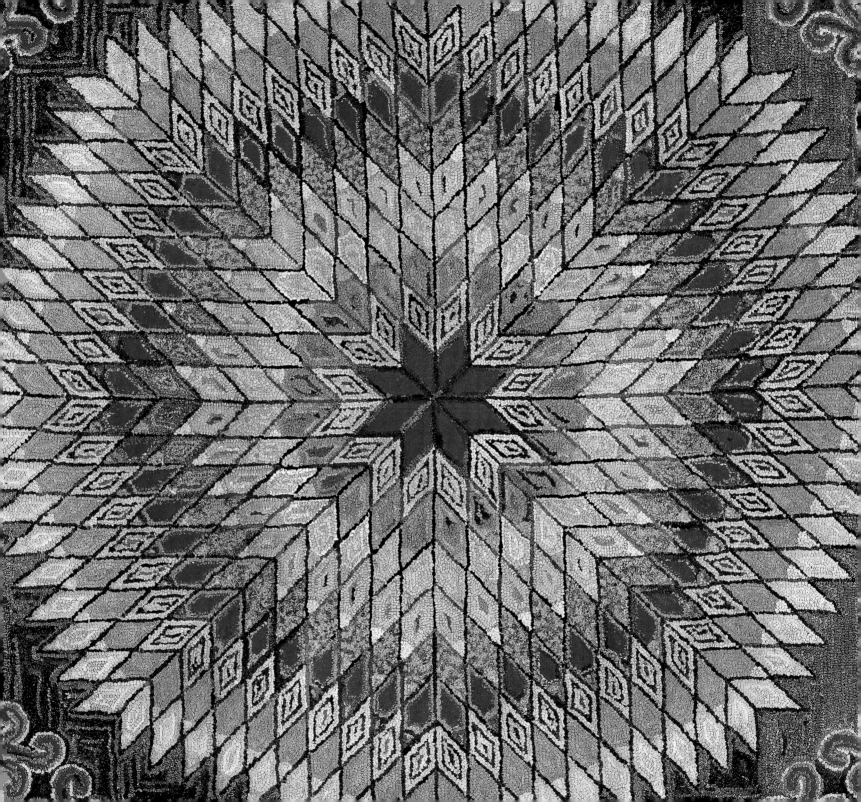

JUDITH A. BARTER AND MONICA OBNISKI

THE COLLECTION

The following entries depict the many faces of folk art—indigenous cultural expressions of artists and artisans who made useful and decorative objects for their friends, families, and clients. From early New Mexican furniture and New England portraits, to Pennsylvania earthenware and Ohio quilts and coverlets, these objects reflect traditions of times and locales that still fascinate and delight us today.

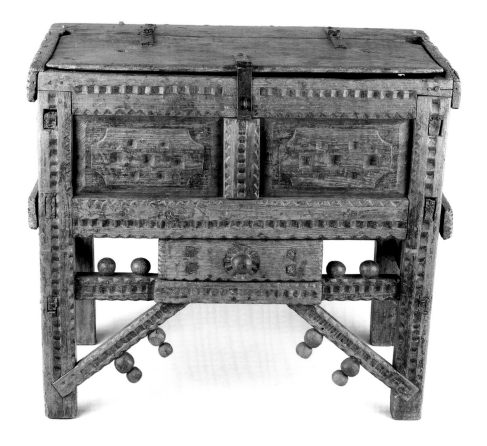

1

Attributed to the Valdés Family
Chest, 1780/1830
New Mexico
Ponderosa pine; 82.6 x 95.6 x
52.4 cm (32½ x 37⅝ x 20⅝ in.)

Restricted gift of an anonymous
donor in honor of Nelson E. Smyth;
restricted gift of Warren L. Batts,
Jamee J. and Marshall Field, Mrs. Frank
L. Sulzberger, and Wesley M. Dixon Jr.,
1986.419

Eighteenth- and nineteenth-century
New Mexican craftsmen made
furniture that was largely based on
Spanish forms and traditions, using
local woods, simple tools, and minimal
decoration. The Art Institute's chest
was likely crafted by a member of
the lauded Valdés family, which
worked for many generations in Taos
County.[1] Chests, both imported and
locally made, were the most common
furniture used in colonial New Mexico

(see fig. 1). Some chests, like the Art
Institute's example, were placed on
stands and would have originally been
vibrantly painted.[2] The construction
of this chest resembles that of others
attributed to the Valdés family, with
simple decoration that includes allover
chip-carved geometric shapes and
applied carved balls.[3] An asterisk,
which appears to mark objects made
by the Valdés family, is located on the
right side of the chest, above a brace.

This chest was part of the collection
of E. Irving Couse, an early Anglo-
American artist who settled in Taos,
founded an art colony, and was an
original member of the Taos Society
of Artists. Although the chest was
published as originating from the
Mission Church of Ranchos de Taos,
this information, given by Couse in a
photograph, has not been substanti-
ated.[4] The chest was photographed in
the Couse living room in Taos, perhaps

around 1910 (fig. 2). Although it is unclear from whom Couse obtained the chest, he could have purchased it directly from the church or through an artist colleague, Burt Phillips, who dealt in New Mexican artifacts.[5] Like artists and collectors in New England in the early twentieth century, many local artists sought to collect and preserve the culture of the Hispanic Southwest through the acquisition of material like this chest.

1. Although the family name has been published as Valdez, genealogical researcher José Antonio Esquibel, who worked out the family's genealogy, confirmed the spelling as Valdés. José Antonio Esquibel and John B. Colligan, "The Spanish Recolonization of New Mexico: An Account of the Families Recruited at Mexico City in 1693," unpub. ms. Relevant pages located in the Files of the Department of American Art, Art Institute of Chicago.

2. The Art Institute's chest bears traces of red and black paint.

3. Donna L. Pierce, "New Mexican Furniture and Its Mexican Prototypes," in *The American Craftsman and the European Tradition, 1620–1820*, exh. cat. ed. Francis J. Puig and Michael Conforti (Minneapolis Institute of Arts/University Press of New England, 1989), p. 183.

4. This was published in Lonn Taylor and Dessa Bokides, *New Mexican Furniture, 1600–1940* (Museum of New Mexico Press, 1987), p. 24. To follow up on this claim, the author contacted Father Francis Malley, current pastor at the San Francisco de Asis Mission Church in Taos, who surveyed the archives; the church possesses a list (or a furnishing plan) of its contents from 1815. To date, the chest has not been located on the inventory.

5. This was suggested by Ernest E. Leavitt, a former curator at the Arizona State Museum and the husband of Couse's granddaughter, in a letter to the Art Institute, Dec. 30, 1996. Files of the Department of American Art, Art Institute of Chicago.

Fig. 2 Photograph of the chest in the Couse living room, c. 1910. Couse Foundation.

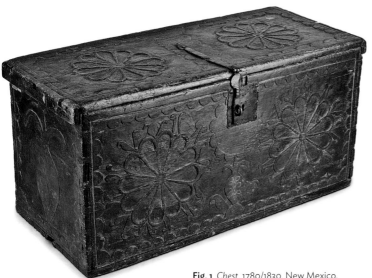

Fig. 1 *Chest*, 1780/1830. New Mexico. Ponderosa pine; 60 x 130.5 x 55.9 cm (23 5/8 x 51 3/8 x 22 in.). The Art Institute of Chicago, Peter McCormick Fund, 1991.106.

2

Jar, 1700/50
Puebla, Mexico
Tin-glazed earthenware; h. 62.9 cm
(24¾ in.); diam. 50.8 cm (20 in.)

Gift of Mrs. Eva Lewis in memory of
her husband, Herbert Pickering Lewis,
1923.1443

Chocolate Jar, 1700/50
Puebla, Mexico
Tin-glazed earthenware and iron;
h. 42.6 cm (16¾ in.); diam. 27.9 cm
(11 in.)

Gift of Mrs. Eva Lewis in memory of
her husband, Herbert Pickering Lewis,
1923.1537

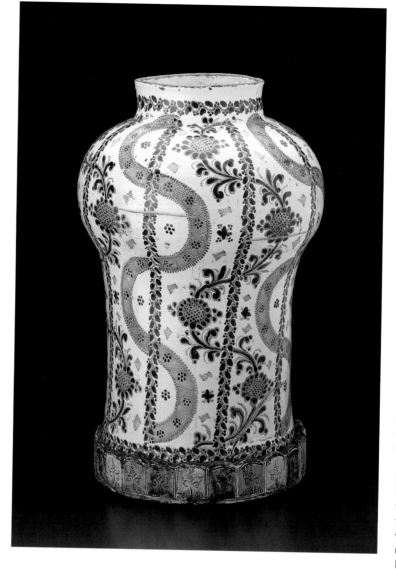

In the wake of the Mexican Revolution of 1911, American artists, diplomats, and businessmen in Mexico collected native crafts and colonial artifacts that represented the roots and history of the new Mexican society. Chicago businessman Herbert Pickering Lewis and his wife, Eva, collected colonial *talavera* ware while living and working in Mexico. After her husband's death, Mrs. Lewis donated their collection of over one hundred objects to the Art Institute. The status of Mexican folk art was elevated in Mexico and the United States as a result of the examination of this material by artists and the pioneering interest of collectors like Emily de Forest and the Lewises.[1] Their fascination became part of a larger trend that gained traction in the 1920s; Mexican folk art was shown at the Metropolitan Museum of Art in 1930 (and traveled to thirteen other venues), and the Art Institute's exhibition of the Florence Dibell Bartlett collection, *Antique Arts and Crafts from Old Mexico*, opened in December 1935. The underlying interest in *talavera*, like Anglo-American folk art, was based on the belief that Mexicans of Indian ancestry were closely aligned with nature and that their innate sense of beauty manifested itself in objects like *talavera poblana*. This sentiment was echoed in a contemporary article that heralded Pueblan potters whose work "shows the rare artistic skill of the natives of the country as applied to European materials and design."[2]

Talavera poblana, a tin-glazed earthenware, was made in the central Mexican town of Puebla beginning in the sixteenth century. The name likely refers to the majolica-producing city of Talavera de la Reina in Spain.

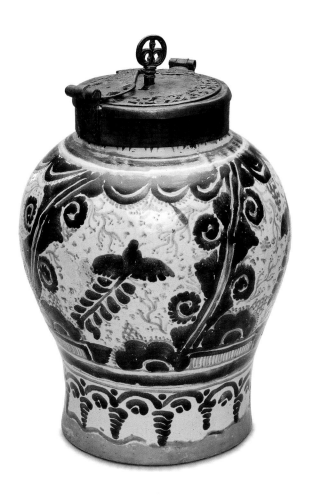

Talavera emulated the designs of fashionable imported Spanish ceramics; like its Spanish prototypes, it showed the influence of Islamic, Chinese, Italian, and French ceramics, all present in cosmopolitan Spain during the fifteenth and sixteenth centuries and transmitted to Mexico during the colonial period. The shape of the Art Institute's first jar resembles that of a Chinese *quan* vessel. Its decorative treatment includes flowering bands and sinuous vines with abstracted sunflower-like blossoms. The blue-and-white body is enlivened by polychrome panels with abstract vegetal motifs at the base of the vessel. The chocolate jar—with an iron cover, collar, and lock—would have been used to store valuable commodities like cacao beans. The blue-and-white ornamentation features panels composed of fringed curtains and scrolled leaves that frame long-tailed birds, a popular Mexican motif that may recall Chinese export Swatow ware. These jars suggest the range and diversity of the Lewises' extensive collection of colonial Mexican earthenware.

1. Helen Delpar, *The Enormous Vogue of Things Mexican: Cultural Relations between the United States and Mexico, 1920–1935* (University of Alabama Press, 1992), p. 133.

2. Jessica Nelson North, "Mexican Faience," *American Magazine of Art* 17 (1926), p. 453.

3

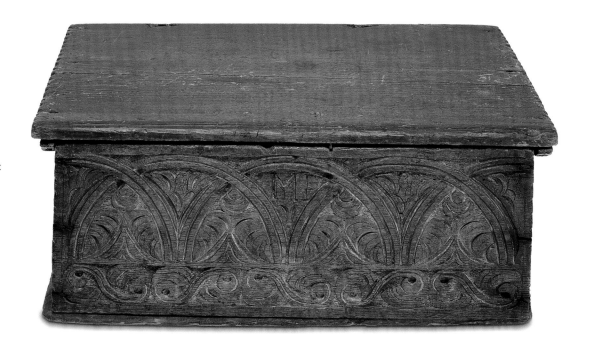

Box
1650/1700
Eastern Massachusetts
Red oak with white pine; 24.8 x 63.4 x
45.7 cm (9 ¾ x 25 x 18 in.)

Wirt D. Walker Fund, 1946.564

Inscribed: *M P*

The most common object in a colonial home, a small, lidded rectangular storage box would have held personal articles, such as household items, writing implements, or a Bible. Such boxes fell out of fashion by 1700.[1] They were decorated simply, usually only on the front, with stylized plants or vegetation and geometric lines. The Art Institute's box is segmented by an upper band of intersecting lunettes with intervening foliate leaves and a lower border with

repeating floral S-scrolls.[2] The initials "M P," carved in the center of the box, are presumably those of the original owner (although his or her identity is unknown).

The box's connection to eastern Massachusetts can be asserted based on its provenance and carved motifs. Before arriving in the Art Institute's collection, it belonged to Mrs. Bernard A. (Margaret) Behrend of Wellesley,

Mr. Frost of Haverhill, Mr. Rogers of Byfield, and the Fewkes family of West Newbury.[3] Although dates of ownership and the history of the box prior to the Fewkeses' possession are unknown, it is significant that the box stayed in eastern Massachusetts. Further, a related box with strikingly similar ornamentation in the collection of the Milwaukee Art Museum (L1983.193) has been attributed to the shop tradition of William Searle

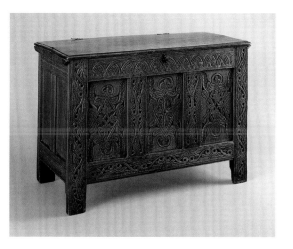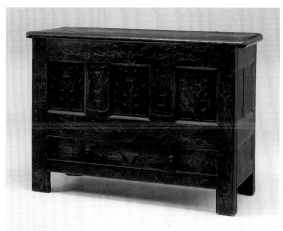

Fig. 1 Attributed to the Searle-Dennis shop tradition. *Chest*, 1670–90. Ipswich, Massachusetts. Red oak and white oak; 72.4 x 106.4 x 50.2 cm (28½ x 41⅞ x 19¾ in.). The Metropolitan Museum of Art, gift of Mrs. Russell Sage, 1909 (10.125.24).

Fig. 2 *Chest*, 1700/10. Hatfield or Deerfield, Massachusetts. Oak with white pine; 82.5 x 122.5 x 48.2 cm (33½ x 48¼ x 19 in.). The Art Institute of Chicago, Robert R. McCormick Charitable Trust Fund, 1979.1459.

and Thomas Dennis. (Originally from Devonshire, England, the pair settled in Ipswich, Massachusetts, in the 1660s.) The same carved decorative motifs of intersecting lunettes and S-scrolls connect this box to a larger group of attributed Searle-Dennis objects with established provenance, such as a chest from Ipswich, Massachusetts (fig. 1).[4]

Unlike quotidian boxes, chests were prized possessions in the colonial era; they and other colonial decorative arts were rediscovered and collected beginning in the late nineteenth century as part of the Colonial Revival fervor. Attaining popularity in the early twentieth century, colonial furniture, including a Hadley chest, was depicted in the *Index of American Design* as emblematic of the nation's heritage, or folk art.[5] Like the Art Institute's box, Hadley chests displayed carved motifs and construction techniques

that also reflected the familial ties of the craftsmen who made them in the Connecticut River Valley (see fig. 2).[6] Whether the floral lunettes (a decidedly English motif) on this box or the tulip and vine motif (which originated in Persian pottery and was later adopted by English craftsmen via Netherlandish Renaissance prints) on the Hadley chest, the decorative vocabulary retained by immigrant craftsmen introduced to the colonies a system of ornamentation that illustrated a shared, vernacular language.[7]

1. Frances Gruber Safford, *American Furniture in the Metropolitan Museum of Art: 1. Early Colonial Period: The Seventeenth Century and William and Mary Styles* (Metropolitan Museum of Art/Yale University Press, 2007), p. 169.

2. This joined white pine and red oak box also has metal hinges, which were a later addition; the nails appear to be original.

3. B. H. Davis, J. Saltzberg Antiques, Ipswich, Massachusetts, to Mrs. B. A. Behrend Jr., Dec. 28, 1937. Files of the Department of American Art, Art Institute of Chicago. This letter outlines the known ownership of the box. Antiques dealer Joseph Saltzberg was known for obtaining material from local collections.

4. Although the Art Institute's box is crudely carved, as Frances Safford suggested of the Metropolitan Museum's chest, it may have been the work of a journeyman vaguely familiar with the shop's craftsmanship. Safford (note 1), p. 200.

5. Virginia Tuttle Clayton, Elizabeth Stillinger, and Erika Lee Doss, *Drawing on America's Past: Folk Art, Modernism, and the Index of American Design*, exh. cat. (National Gallery of Art, 2002), p. 132.

6. For a discussion of the Art Institute's chest, see Judith A. Barter, ed., *American Arts at the Art Institute of Chicago* (Art Institute of Chicago/Hudson Hills Press, 1998), pp. 51–53.

7. Additionally, the international seventeenth-century idiom of Mannerism was admirably dissected by Glenn Adamson, whose article builds upon previous scholarship and revisits the term in light of Joseph Manca's critique. Glenn Adamson, "Mannerism in Early American Furniture: Connoisseurship, Intention, and Theatricality," *American Furniture* (2005), pp. 22–62.

4

Attributed to Robert Crosman
(1707–1799)
Chest-over-Drawer, c. 1725
Taunton, Massachusetts
White pine, iron, brass, and painted
decoration; 52.8 x 57.2 x 32.6 cm
(20 ¾ x 22 ½ x 12 ¹³/₁₆ in.)

Wirt D. Walker Fund, 1946.561

Inscribed in paint: *H B*

This chest belongs to a group of
furniture attributed to drum maker
and joiner Robert Crosman, who likely
learned the furniture-making trade
from family members. The piece's
simple plank construction is charac-
teristic of Crosman's work.[1] The chest rests
on two feet formed by semicircular
cutouts on the side planks. Although
the flat top is undecorated, a white
tree with ocher leaves and red flower-
ing buds, and four birds surround the
initials "H B" on the central panel. On
the drawer below are four additional
birds that are barely visible today.
The chest includes an iron lock plate
and a pull with a brass pierced back

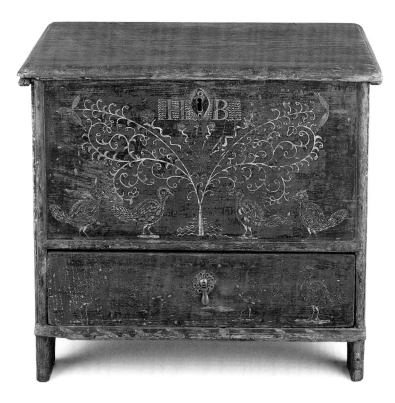

plate. The backboard bears a painted
inscription that is mostly illegible.[2]

Crosman's work was resurrected by
Esther Stevens Fraser in the early
1930s, as interest in folk art was
emerging in the United States.[3] Early
painted chests were likely made for
young women as dowry vessels. The
inclusion of women's initials on chests,
as well as the use of a decorative
vocabulary that bespeaks fertility and
prosperity, supports this long-standing

view. The initials on known Crosman
chests are thought to be those of
his sisters and other women in his
family. Records suggest that he had
three wives: Martha Gachet, Desire
Blake, and Prudence Hayward.[4]
The initials on this chest could be
those of Hannah Blake, a relative of
Crosman's second wife. Not much is
known about Blake: she was born in
Dorchester, Massachusetts, on March
3, 1705; married Jonathan Payson on
March 11, 1725; and died on September

15, 1784.[5] The form and simple decora-
tion of this chest, which most closely
resembles one in the collection of
Colonial Williamsburg (1971.2000.1),
suggest that it was crafted early in
Crosman's career. It was likely cre-
ated around 1725, near the date of
Blake's marriage.

1. Additionally, Crosman's distinctive decora-
tion includes C-scrolls, compass-drawn vines,
and repeating motifs of birds and trees.

2. Examined and photographed using infrared
technology, the script is largely illegible. The
first line indicates "R O C" or "R D C," but
the rest is obscured. The second line reads
"Hamp . . ." The third line begins with *S*, and
the fourth line is illegible. The author would
like to thank Kelly Keegan, Andrew W. Mellon
Fellow of Paintings Conservation, Art Institute
of Chicago, for her work on this chest.

3. Esther Stevens Fraser, "The Tantalizing
Chests of Taunton," *Magazine Antiques* 23
(Apr. 1933), pp. 135–38.

4. Ibid., p. 136.

5. William R. Cutter and William F. Adams,
*Genealogical and Personal Memoirs Relating to
the Families of the State of Massachusetts,* vol. 2
(Lewis Historical Publishing Company, 1910),
p. 1219.

5

Rudolph Drach (1759–after 1814)
Plate, 1792
Bedminster Township, Pennsylvania
Redware; diam. 28.7 cm (11⁵⁄₁₆ in.)

Field Museum Exchange, 1907.122

Inscribed: *rudolf drach / hefner in
bädminster / daunschib / 1792*

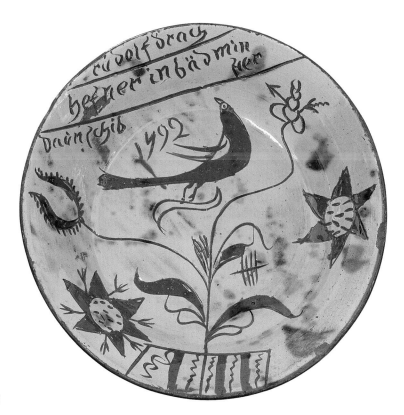

Little is known about the potter of
this plate, Rudolph Drach. The artist's
grandfather Rudolph Drach was among
seventy-seven Palatinate Germans
who, along with their families, arrived
in Philadelphia on August 29, 1730,
aboard the ship *Thistle*.[1] Drach mar-
ried, and by 1750 he and his wife, Maria
Elizabeth, were in Bucks County,
where their daughter, Anna Maria,
was born. The couple also had two
sons, John Adam and Henry, to whom
Rudolph bequeathed three hundred
acres of land in Rockhill Township,
Bucks County. He died in 1771.[2]

Rudolph was a family name. The
maker of this vessel, John Rudolph
Drach, was born to Henry and Anna

Maria Drach on October 16, 1759,
and was baptized on November 18.[3]
A cousin with the same name was
born to John Adam and Eva Drach on
August 19, 1770. Drach's cousin moved
to Hamilton Township in Monroe
County, Pennsylvania; thus, he cannot
be the potter of this vessel.[4] The same
tract of land that was conveyed to
Henry by his father was given to his
son, who then transferred thirty-one
acres on March 2, 1787, to someone
else. This transaction places the potter
in Bedminster Township near the date
that the plate was made.[5]

This plate, made by Rudolph Drach
in 1792 according to the incised
inscription, was originally in the col-
lection of Edwin Atlee Barber and
was illustrated in his *Tulip Ware of the
Pennsylvania-German Potters* (1903).[6]
Sgraffito decoration—the act of incis-
ing the surface to reveal the clay body
beneath—characterizes many of the
ceramics created in Bucks County
in the Pennsylvania German tradi-
tion. Such pottery features exuberant
colors and ornamentation through
traditional decorative motifs, including
the bird, tulip, and star shapes that
decorate this plate.

1. Carl Boyer III, ed., *Ship Passenger Lists:
Pennsylvania and Delaware (1641–1825)* (Boyer,
1980), p. 57.

2. Frances Wise Waite, ed., *Bucks County
Tombstone Inscriptions: Bedminster and Haycock
Townships* (Bucks County Genealogical
Society, 1988), p. K18.

3. William John Hinke, ed. and trans., *A History
of the Tohickon Union Church, Bedminster
Township, Bucks County, Pennsylvania* (Press of
the Tribune Pub. Co., 1925), p. 104.

4. David Henry Keller, *The Kellers of Hamilton
Township: A Study in Democracy* (Wall Printing
Co., 1922), p. 37.

5. Drach conveyed the parcel to Adam Yost.
See William W. H. Davis, *History of Bucks
County, Pennsylvania: From the Discovery of
the Delaware to the Present Time*, vol. 1, 2nd ed.
(Lewis Pub. Co., 1905), p. 62.

6. Edwin Atlee Barber, *Tulip Ware of the
Pennsylvania-German Potters: An Historical
Sketch of the Art of Slip-Decoration in the United
States* (Patterson and White Co., 1903), pp.
117–18. The Winterthur Museum also owns a
plate signed by Drach (67.1609) and another
attributed to him (67.1608).

6

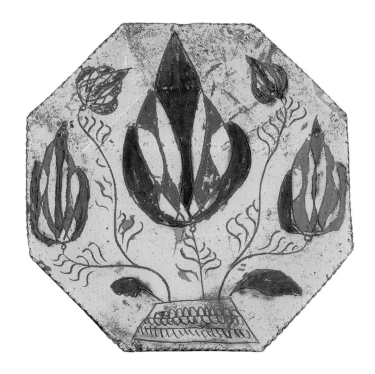

Plate, 1780/1820
Pennsylvania
Redware; diam. 23.5 cm (9¼ in.)

Atlan Ceramic Club Fund, 1923.313

Unlike the Art Institute's plate by Rudolph Drach (cat. 5), on which the maker inscribed his name, many objects in the Pennsylvania German tradition are unmarked, obscuring authorship for subsequent generations. Creamy white slip (which appears yellow due to the lead glaze on top of it) was applied to the surface of this plate, onto which sgraffito decoration was incised. The addition of lightly applied copper oxide created green accents across the plate. Pennsylvania German vessels are further characterized by bold designs of tulips, stars, and hearts. This octagonal plate incorporates another traditional motif—the stylized pomegranate. Other Pennsylvania German pottery in the Art Institute's collection bearing this motif includes a jar (missing its cover) with sgraffito decoration of tulips flanking a central pomegranate

above a heart with the date 1795 (fig. 1). In the past, the Art Institute's unmarked plate was attributed to Jacob Taney (although, according to more recent scholarship, it may actually be by Jacob Tingley[1]) of Bucks County based on its shape; however, there are considerable differences that preclude it from inclusion in the established group of octagonal plates marked "IT" (for Tingley) in the collections of the Philadelphia Museum and Winterthur Museum.[2] The plates at Winterthur and Philadelphia are just over 8½ inches in diameter; the Art Institute's plate is 9¼ inches in diameter. On the other plates, the surface

decoration stands in relief above the dark-red ground; the Art Institute's plate is slip- and sgraffito-decorated in a standard Pennsylvania German vocabulary. Finally, the initials "IT" and a date appear on the Philadelphia and Winterthur plates; the Art Institute's plate does not bear any indication of a date or maker. Although such octagonal mold-assisted plates are very rare, an attribution of this example to Tingley is not likely.[3]

1. Alexandra A. Kirtley, Montgomery-Garvan Associate Curator of American Decorative Arts, Philadelphia Museum of Art, e-mail correspondence with the author, Dec. 8, 2010.

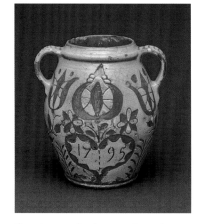

Fig. 1 *Jar*, 1795. Southeastern Pennsylvania. Redware; 18.2 x 17.8 x 15.6 cm (7⅛ x 7 x 6⅛ in.). The Art Institute of Chicago, Atlan Ceramic Club Fund, 1923.263.

Interestingly, Kirtley explained that the decorative scheme on the Philadelphia octagonal plate (1901–07) is closely related to those found on salt-glazed stoneware.

2. The Philadelphia Museum plate's accession number is 1901-07 and Winterthur's is 65.2306.

3. Unrelated to any of the above-mentioned dishes, another unmarked, eight-sided Pennsylvania German dish exists in the collection of the Mercer Museum (17384).

7

Attributed to Sally Standish
Pocket, c. 1799
Massachusetts or Rhode Island
Cotton, plain weaves; some
embroidered with silk in chain and
cross stitches; some printed; pieced;
edged with cotton, plain weaves, some
printed; lined with linen; 37.2 x 32.4 cm
(14 ⅝ x 12 ¾ in.)

Elizabeth R. Vaughan Endowment,
2007.356

During the eighteenth and early
nineteenth centuries, women's cloth-
ing was not constructed with sewn-in
pockets. Pockets of this period were
separate accessories used for carrying
small personal items. Usually shaped
like oblong trapezoids and made in
pairs, pockets were attached by long,
narrow tapes that tied around the
waist. They were concealed beneath
skirts and accessed by slits or open
seams.[1] Although hidden from view,
they could be lavishly embellished,
intricately constructed, or personal-
ized by the maker.

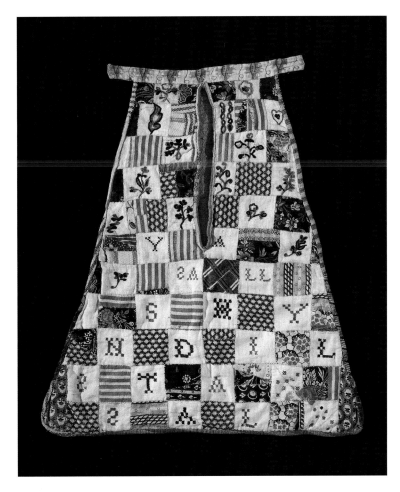

This pocket displays a combination
of printed textiles (probably saved
dress and lining fabrics) and white
fabric embroidered with silk. Although
functional, it shows the maker's
creative expression through the
arrangement and choice of fabrics in
the small pieced blocks. Additionally,
it is personalized with embroidered
floral motifs, a small heart on the
upper-right side, and the maker's
name.[2] The maker demonstrated
her sewing skills by piecing together
multiple fabrics within several of the
small blocks. The pocket may have
functioned as a practice piece for a
larger project, perhaps a pieced bed-
cover. The development of domestic
skills like sewing and embroidery was
of educational importance, as the
proliferation of needlework samplers
demonstrates (see cat. 27). This
pocket displays sewing and needle-
work techniques that would have
been essential for the laborious task
of maintaining, mending, and marking
household linens and clothing.

During this period in the United
States, textiles—whether homespun
or imported—were considered a pre-
cious commodity, as the utilization of
saved scraps for the creation of this
pocket makes clear. Even the small-
est bits of fabric were retained and
used for other projects. Although the
production of pockets was the result
of practicality and need, the construc-
tion of such pieces offered the maker a
vehicle for personal expression.
—*Odile Joassin*

1. Linda Baumgarten, *What Clothes Reveal: The
Language of Clothing in Colonial and Federal
America* (Colonial Williamsburg Foundation,
2002), pp. 56–58.

2. Based on an old handwritten piece of paper
that accompanied the pocket, the maker
was Sally Standish, which can be spelled
out from the jumble of letters on the lower
half. Unfortunately, there are no conclusive
records linking this pocket to a specific Sally or
Salome Standish.

8

Wardrobe (Schrank), c. 1790
Berks County, Pennsylvania
Tulipwood, brass, iron, and painted
decoration; 204.5 x 176.5 x 56.9 cm
(80 x 69½ x 22¼ in.)

Elizabeth R. Vaughan Fund, 1956.761

Inscribed in paint: *17 John Weidner 90*

The German cabinetmaking tradition
thrived in Pennsylvania, especially the
crafting of wardrobes (*schranken*),
which were similar to New York–made
Dutch cupboards (*kasten*) (see fig. 1).
This brightly painted, monumental
wardrobe was used in a Pennsylvania
German home for storing clothing,
textiles, and other valuables. As the
inscription on the pediment reveals,
it was made for John Weidner around
1790. The wardrobe was likely made
for either the John Weidner born to
Lazarus Weidner (1723–1802) and
Elizabeth Yoder (1720–1782) in 1757
in Oley Township, Berks County, who
married Anna Margaretha Cunnius on
May 5, 1788, and died in Upper Milford
Township, Lehigh County, in 1837; or his
cousin John Weidner, who was born in

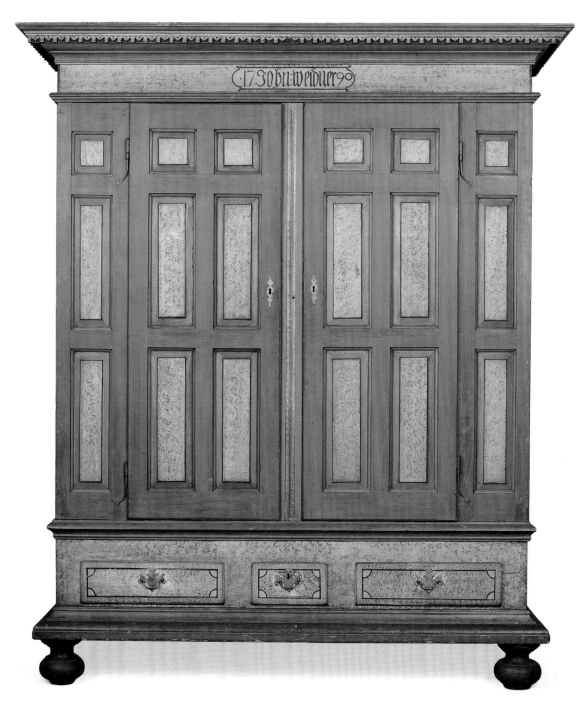

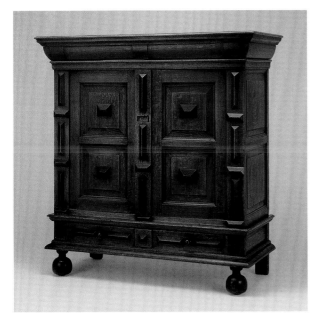

Fig. 1 *Kast*, 1650/1700. New York. Oak and walnut; 170.8 x 168.3 cm (67 ¼ x 66 ¼ in.). The Art Institute of Chicago, Sanford Fund, 1949.489.

Fig. 2 *Schrank*, 1775. Berks County, Pennsylvania. Pook and Pook, October 30, 2010, lot 255.

1756 to Tychicus (brother of Lazarus) Weidner and Anna Maria Hill in Oley Township, Berks County, married Catherine Borgert on January 30, 1793, and died in 1836 in Oley Township.[1] Resting on four bun-shaped feet, the wardrobe case utilizes a vibrant palette of blue and red, with a carved cornice of diamond molding and a sponge-painted pediment, panels, and base with drawers. The history of the piece prior to its acquisition by Imogene (Mrs. Leroy) Walker in 1923 from the Pennsylvania dealer Augustus Pennypacker, who allegedly found it in a barn, is unknown.[2] A letter from Walker reveals a highly romantic story: when she and her husband purchased this dust-covered *schrank*, she purportedly scrubbed it with Bon Ami

scouring powder to reveal the splatter pattern and brilliant blue paint.

Although the synthetic pigment Prussian blue was available in the United States during the early eighteenth century, this object features some areas of overpaint (layers of paint that cover up an underlayer). The bright-blue paint includes a mixture of zinc oxide and barium sulfate, identifying it as a later paint addition, as zinc oxide was not available until around 1850; this layer of overpaint is present above an original ground layer of lead white and Prussian blue. Thus, significant areas of original polychromy exist, including the exuberant sponge painting, along with some areas of overpaint.[3]

A comparable painted *schrank* made for Philip Detuk in 1775 was recently sold at auction (fig. 2).[4] Interestingly, Detuk, like Weidner, lived in Oley Township, Berks County, thus suggesting that the same craftsman could have made both wardrobes. Significantly, both objects were discovered by Pennypacker in the early twentieth century, further implying a common source.[5]

1. Unfortunately, the inventories provided by the Register of Wills, County of Berks, Pennsylvania, offer few clues. The only wardrobe mentioned in John Weidner's 1837 inventory (Hereford Township) is a *kuchen-schrank*. John Weidner's 1836 inventory (Oley Township) only lists a vendue sale. Although the *schrank* was not part of the vendue, it could have been kept by Weidner's widow or another heir. The author would like to thank Lisa Minardi, Assistant Curator of Furniture for the

Southeastern Pennsylvania Furniture Project, Winterthur Museum, for her assistance with these inventories.

2. Files of the Department of American Art, Art Institute of Chicago.

3. Although analysis of the red pigment was inconclusive, experiments point to the use of an early synthetic colorant from the late nineteenth century, suggesting that the vibrant sections of red may also be overpaint. The author would like to thank Inge Fiedler and Francesca Casadio in the Department of Conservation Science at the Art Institute for providing a thorough analytical report.

4. The wardrobe appeared in the Oct. 30, 2010, sale, Pook and Pook, Inc., lot 255.

5. "Masterpieces of Early American Furniture in Private Collections," *Magazine Antiques* (Nov. 1937), p. 226.

39

9

Samuel Gragg (1772–1855)
Side Chair, 1808/12
Boston, Massachusetts
Oak, ash, maple, and painted
decoration; 86.4 x 45.2 x 49.5 cm
(34 x 17¾ x 19½ in.)

Wirt D. Walker Fund, 1970.40

Marked under front seat rail:
S. GRAGG / BOSTON

An innovator in American chair making, Boston furniture maker Samuel Gragg created fashionable and inventive furniture through the clever manipulation of an ancient woodworking technique. Although he made "bamboo" (or Windsor) chairs more frequently, his "elastic" chairs would solidify his place in the annals of American furniture. Gragg was issued an elastic-chair patent on August 31, 1808. While his exact technological process has not been fully identified, we know that he used steam to bend the structural parts of the chair, as the stiles and seat of this example demonstrate.[1] The Art Institute's piece is one of Gragg's first elastic chairs; the outside stile and seat rail are of one piece, with the front leg attached. In his later "fully elastic" model, the stile, seat, rail, and leg were all made of one piece of bent wood.[2]

Reflecting the taste for Classicism in the United States, the profile of this chair is derived from the ancient *klismos* chair, a form available to designers during the early nineteenth century, as a result of the archaeological excavations of the period. The similarity between the profile of Gragg's chair and an illustration of a *klismos*-type

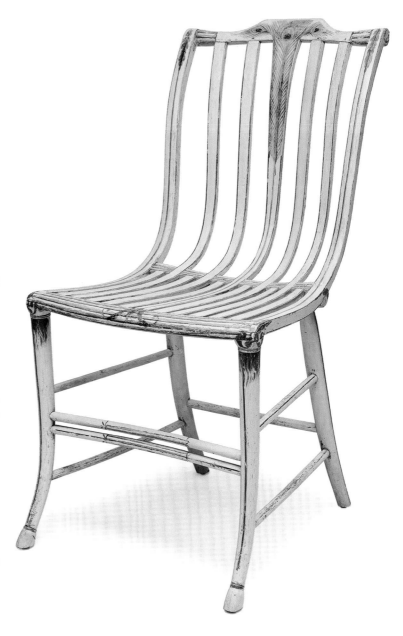

chair in Thomas Hope's *Household Furniture and Interior Decoration* suggests the maker's awareness of contemporary fashionable taste.[3] This type of classically derived furniture was quite popular in the early nineteenth century. For example, Gragg's chair resembles a Philadelphia high-style *klismos* chair with decoration painted by John Philip Fondé (fig. 1). The decoration on the Gragg chair was likely not painted by him but by an ornamental painter in Boston. During this period, the supply of excellent decorative painters was abundant, and one of them could have painted the delicately rendered peacock feathers gracing the crest rail and back splat, as well as the various decorations that terminate in a hoof foot.

1. Patricia E. Kane, "Samuel Gragg: His Bentwood Fancy Chairs," *Yale University Art Gallery Bulletin* 33 (Autumn 1971), p. 27.

2. Michael Podmaniczky, "The Incredible Elastic Chairs of Samuel Gragg," *Magazine Antiques* (May 2003), p. 144.

3. Kane (note 1), p. 34.

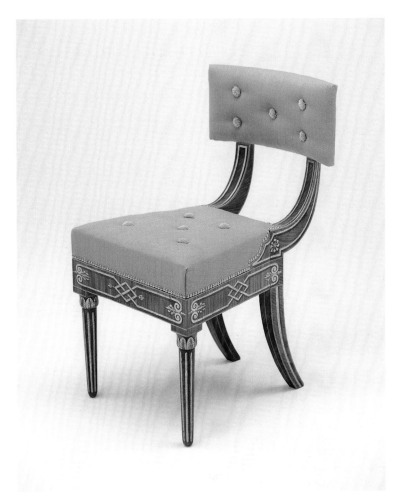

Fig. 1 Maker unknown, decorated by John Philip Fondé (1794–1831). *Side Chair*, c. 1816. Philadelphia, Pennsylvania. Ash, white pine, white oak, and painted decoration; modern upholstery; 81.3 x 40 cm (32 x 15 ¾ in.). The Art Institute of Chicago, gift of James Biddle, 1970.436.

10

John Ritto Penniman (c. 1782–1841)
Meetinghouse Hill, Roxbury, Massachusetts, 1799
Oil on canvas; 73.6 x 94 cm
(29 x 37 in.)

Centennial Year Acquisition and the Centennial Fund for Major Acquisitions, 1979.1461

Born in Milford, Massachusetts, John Ritto Penniman trained as a decorative painter and executed his earliest pictures for the Roxbury clockmaker Aaron Willard, who commissioned *Meetinghouse Hill* from the seventeen-year-old artist.[1] This composition is Penniman's first recorded easel painting and provides an accurate and rare view of a prosperous New England town.

Roxbury was already old by the turn of the nineteenth century. Settled in 1630, it counted among its citizens many distinguished artisans and craftsmen of the early republic. Penniman supposedly painted this view from the center of town, near Willard's shop, which provided a panorama of the village. The artist approached his work as a documentarian, and his topographical accuracy allows us to identify some of the town's landmarks: the meetinghouse was the fourth to stand on the spot,

and it was soon destroyed by fire (1803); the Spooner-Lambert-Tabor House, located to the left of the meetinghouse, is still standing; and the 1751 gambrel-roofed parsonage is off to the right.

Penniman carefully delineated animals grazing on the enclosed commons, farmers pushing wheelbarrows, and a covered wagon on the road, exhibiting the exacting craft of the ornamental painter: carefully controlled brushstrokes; a bright, if limited palette; simple, unmodeled forms; sharp contrasts between light and dark; and an awkward perspective. The clarity with which Penniman painted each element may also reflect his sense of national identity. His emphasis on the meetinghouse proudly points to the fact that the citizens of Roxbury were the ancestors of colonists who created a "city upon a hill," a theocratic utopia committed to homogeneous spiritual bonds of citizenship.

These hard-working people imposed order upon the wilderness. This work differs greatly from the more famous American landscapes of the mid-nineteenth century, in which painters eschewed mere topographical tradition in favor of an unsettled, wilder landscape symbolizing national identity and individual freedom.

1. Penniman's earliest known painting is a signed clock dial from 1793; see Carol Damon Andrews, "John Ritto Penniman, 1782–1841: An Ingenious New England Artist," *Antiques* 120, 7 (July 1981), p. 148. Penniman painted fireboards, tinware, fire buckets, and coaches, and executed reverse painting on glass for looking glasses and clocks. He also painted still lifes on furniture (see the commode by Thomas Seymour, owned by Elizabeth Derby of Salem, now in the Museum of Fine Arts, Boston). He advertised these skills in Boston's *Saturday Evening Gazette* on Oct. 12, 1822.

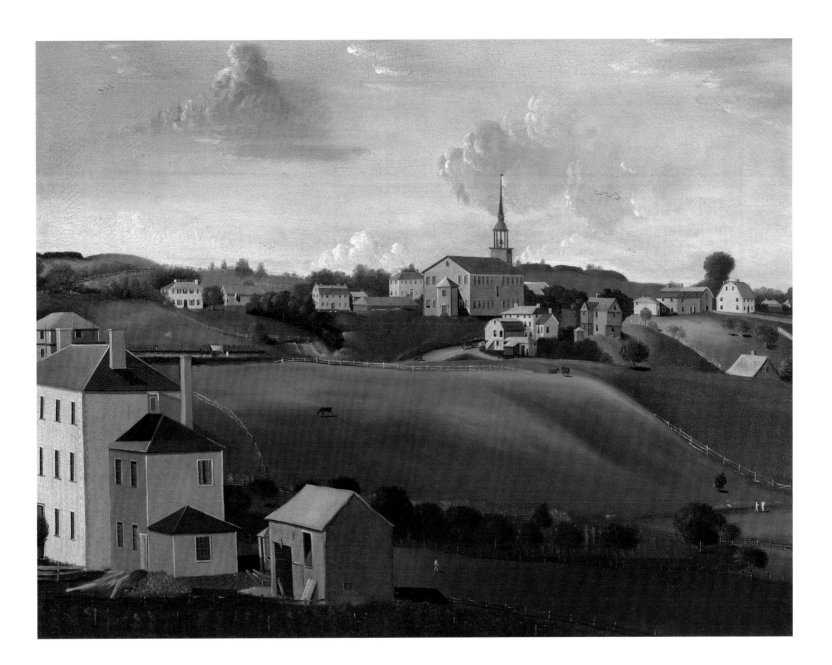

II

Ammi Phillips (1788–1865)
Mrs. Reuben Allerton (Lois Atherton),
1820/22
Cornelius Allerton, 1821/22
Oil on canvas; 84.1 x 69.5 cm
(33 x 27½ in.)

Gift of Robert Allerton, 1946.394–95

Ammi Phillips was one of eleven children born to Samuel and Milla Kellogg Phillips in Colebrook, a town on the Connecticut-Massachusetts border. The self-taught, itinerant portrait painter plied his trade in western Connecticut, western Massachusetts, and New York. Phillips first appeared as a professional portrait painter in a July 29, 1809, advertisement placed in the *Berkshire Reporter* (Pittsfield, Massachusetts), in which he promised to paint likenesses and profiles over the following weeks in his room at Clarke's Tavern.[1] His early portraits, from the period 1811–14, are often awkward, stiff, barely modeled representations of his sitters. Phillips married Laura Brockway in 1813, and the couple and their children soon settled in Troy, New York, where he might have seen the work of the well-known portraitist Ezra Ames. Around 1817 he moved his family to Dutchess County, New York, where he worked for more than thirty years.

The son of a Revolutionary War veteran, and a doctor in Pine Plains, New York, Cornelius Allerton was forty-two years old when Phillips painted him. In an accompanying portrait of his widowed mother, the severe, wrinkled Mrs. Allerton wears a stiff bonnet, denoting her age. Both subjects were painted in three-quarter length, seated on fancy painted chairs, and shown holding identifying symbols associated with their work. Mrs. Allerton has in her hand the *Gospel Herald*, an evangelical newspaper published in New York City between 1820 and 1827, reflecting the religious awakening coursing through New England in the first quarter of the nineteenth century, which was particularly of interest to women. The inclusion of the proselytizing newspaper symbolizes Mrs. Allerton's moral guardianship of and stature in the community.[2] Many women of her time and class were drawn to temperance and women's-rights movements as a part of their religious beliefs.[3] In contrast, Cornelius holds a volume of *Parr's Medical Dictionary* on his lap, and his saddled horse appears in the distant background, ready to go at a moment's notice. As a pair—a man of science, out in the world, complete with fashionable hair and a jabot; and a plain woman of religion—they represent the separate spheres of men and women in the nineteenth century. Unified by similar somber gray backgrounds and graphic simplicity, these portraits epitomize Phillips's style from the period around 1821–22.

1. Stacy C. Hollander and Howard P. Fertig, *Revisiting Ammi Phillips: Fifty Years of American Portraiture*, exh. cat. (Museum of American Folk Art, 1994).

2. Judith A. Barter, ed., *American Arts at the Art Institute of Chicago* (Art Institute of Chicago/ Hudson Hills Press, 1998), pp. 161–62. Kimberly Rhodes, who wrote the entries on Phillips in that volume, redated the paintings based on the masthead style of the newspaper, which was in use between Apr. 1821 and Apr. 1822. The first volume of *Parr's Medical Dictionary* was published in 1819.

3. Mary P. Ryan, *Cradle of the Middle Class: The Family in Oneida County, New York, 1790–1865* (Cambridge University Press, 1981).

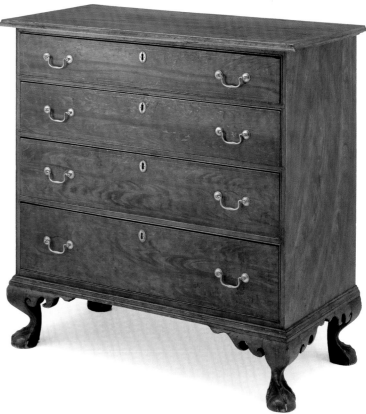

12

Attributed to John Dunlap
(1746–1792) and/or Samuel Dunlap
(1752–1830)
Chest of Drawers, 1780–1810
New Hampshire
Soft maple and eastern white pine
with faux-painted wood grain; 96.8 x
99.7 x 50.2 cm (38⅛ x 39¼ x 19¾ in.)

Vance American Art Fund; restricted
gift of Carol W. Wardlaw, and Jamee J.
and Marshall Field; Americana Fund,
2007.1

Attributed to Samuel Dunlap
(1752–1830)
Candle Stand, 1800–15
Salisbury, New Hampshire
Partially painted maple; 68.6 x 41.3 cm
(27 x 16¼ in.)

Restricted gift of Jamee J. and
Marshall Field, 1999.681

The New Hampshire Dunlap family
of cabinetmakers was part of the
wave of Scotch-Irish immigration
to New England during the early
eighteenth century. Indeed, place
names in New Hampshire and western
Massachusetts—for example, Antrim,
Charlemont, Colrain, Dunbarton,
and Londonderry—reflect the influx
of Presbyterians from Ulster and
Scotland to the area. While religious
tolerance was one reason for this
exodus from the British Isles, the
major factor was famine.

The patriarch of the Dunlap fam-
ily was Archibald, who worked as a
weaver in Chester, New Hampshire.
His sons, John and Samuel, trained
with an unidentified cabinetmaker
and worked in a series of towns in the
south-central area of the state—John
in Goffstown and Bedford, and Samuel
in Goffstown, Bedford, Henniker, and
Salisbury.[1] Signed or labeled pieces by
either John or Samuel are extremely
rare, and although the two worked
independently from 1780 on, scholars
have difficulty identifying characteris-
tics that separate their work. The chest
of drawers attributed to John and/
or Samuel shares with other exam-
ples many elements characteristic of

Dunlap family design, including its
large size, the overhanging top and
narrow beading around the drawers,
boldly scrolled double knee brackets,
sharply angled legs and slender ankles,
fully developed rear feet, and ducklike
ball-and-claw feet.[2]

Rural cabinetmakers often tried to
emulate higher-style urban furniture
made with more exotic woods through
the use of painted finishes. This chest,
made of soft maple and eastern

white pine, was painted with a faux
wood-grain pattern. Although worn,
the original finish is still visible, and its
reddish hue suggests that it simulated
the flamelike whorls of mahogany.

The candle stand attributed to Samuel
also retains its original painted finish.
A historically transitional piece, this
eighteenth-century form exhibits a
small size that was somewhat rare
at the turn of the century, while the
cheerful mustard color with remnants

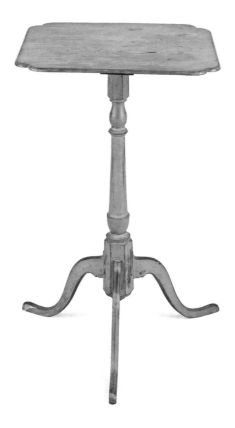

of a red wash is a reminder of the penchant for painted furniture during the early nineteenth century.³ Older styles and forms were retained longer in rural areas than in cities, where the fashionable and new were important status symbols.

The candle stand is almost identical to several other examples that can be traced to the Dunlap family account books.⁴ Samuel sold fifteen candle stands between 1802 and 1814.⁵ The square chamfered top of this example has delicately rounded, notched corners and is attached to a turned baluster shaft by means of a cleat that slides into a channel cut into the underside of the top. The sweeping legs ending in delicate pad feet are characteristic of Dunlap craftsmanship. The feet are tenoned and pinned into rectangular mortises on three sides of the hexagonal block at the bottom of the shaft. These two examples of Dunlap family furniture reflect their rural yet sophisticated cabinetry and palette, as well as the insular influences of shared culture and traditions.

1. John, the elder Dunlap brother, moved to Goffstown in the late 1760s and to Bedford in 1777. Samuel joined his brother in Goffstown by 1773 and, with the exception of his service in the Continental Army in 1775–77, worked intermittently for his brother as a cabinetmaker in Goffstown and Bedford until 1780. In 1780 Samuel moved to Henniker and in 1797 to Salisbury. John also worked as a toll and looking-glass maker, cooper, wheelwright, wagon maker, millwright, maker of coffins, and farmer. See Charles S. Parsons, *The Dunlaps and Their Furniture*, exh. cat. (Currier Gallery of Art, 1970).

2. This example, unlike another chest of drawers at the Winterthur Museum, lacks the flowered ogee molding above the brackets and feet. Another example of a Dunlap piece without the flowered ogee molding is a desk in the collection of the Yale University Art Gallery.

3. Philip Zea and Donald Dunlap, *The Dunlap Cabinetmakers: A Tradition in Craftsmanship* (Stackpole Books, 1994), p. 66.

4. This candle stand is remarkably similar to one at the New Hampshire Historical Society. See ibid.

5. Ibid.

13

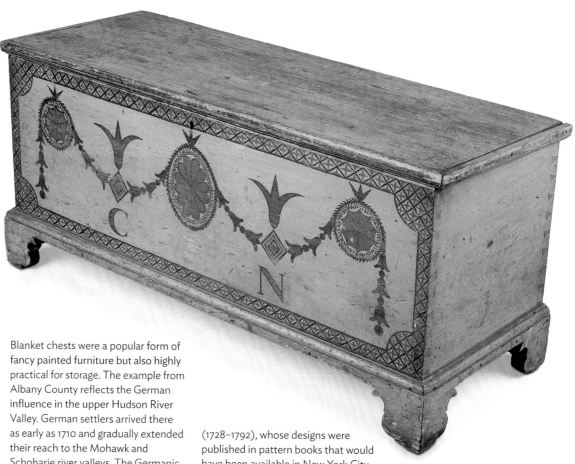

Artist unknown
Blanket Chest, 1805/20
Albany County, New York
White pine and painted decoration;
54 x 124.4 x 46.6 cm (21¼ x 49 x 18⅜ in.)

Gift of the Antiquarian Society
through the Juli and David Grainger
Fund, 1986.191

Inscribed in paint: *C N*

Artist unknown
Blanket Chest, 1836
New England
White pine and painted decoration;
57.2 x 111.7 x 45.7 cm (22½ x 44 x 18 in.)

Juli and David Grainger Endowment,
1994.537

Inscribed in paint under lid: *Geo WR;
Nov. 1 1829; Rec'ed cash $5*

Blanket chests were a popular form of fancy painted furniture but also highly practical for storage. The example from Albany County reflects the German influence in the upper Hudson River Valley. German settlers arrived there as early as 1710 and gradually extended their reach to the Mohawk and Schoharie river valleys. The Germanic features of the chest are its large size and length, and the mounting of the case on a molded base with scrolled bracket feet. Although it displays a tulip, a favorite motif of German and Dutch decoration, English fashions were also incorporated into the chest, mirroring the predominant culture and styles of the time. The pastel coloring, ovoid paterae decoration, wreaths, and festoons of bellflowers were all adapted from the drawings of Scottish Neoclassical architect Robert Adam

(1728–1792), whose designs were published in pattern books that would have been available in New York City during the Federal period. The patterns of the paterae and bellflowers were carefully laid out with a compass and nail before painting began. Perhaps commissioned as a marriage or dower chest, this example displays the initials of its unknown owner. A practically identical chest is in the collection of Colonial Williamsburg.

Also Neoclassical in taste is the Art Institute's later canary-yellow painted blanket chest of New England origin.

Unlike the carefully decorated Albany chest, this example seems to have been painted quickly and freehand, as tendrils loop and trail asymmetrically over its surface. Its Empire-style decoration is heavier and more florid than that of the earlier chest; the vase of flowers painted on the top and side is undulating, with heavy black outlines, and the bun feet are heavy and squat. The vase of flowers is not unlike those painted on fireboards during this

period (see cat. 15). The striking color of the chest is often found on painted Connecticut furniture made between 1800 and 1850, including washstands, chairs, boxes, and chests. While dated 1836, the chest features a partly legible inscription with the name "Geo WR," the date "Nov. 1 1829," and "Rec'ed cash $5" under the lid. Possibly the maker sold the chest to another owner, who later painted it.

Painting furniture disguised the use of common woods and made products cheaper to produce while still emulating high style. These two chests were made in rural areas, but painted furniture also appeared in urban areas, such as Boston during the Federal period (see cat. 9) and Philadelphia during the Empire era (see fig. 9.1). In the latter case, fashionable French Empire chairs were carefully painted to suggest ormolu (a gilded base-metal ornament that was attached to furniture to enrich and embolden the design).

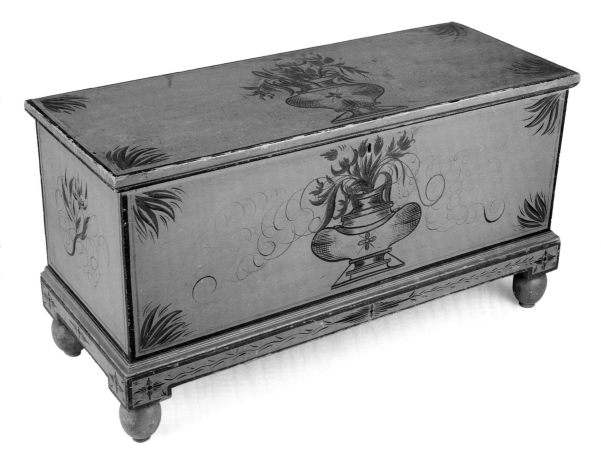

14

Memorial Sampler, c. 1810
Stitched at Mary (Polly) Balch's School
Providence, Rhode Island
Silk, warp-float faced 4:1 satin weave;
embroidered with silk and silk chenille
in split, surface satin, and stem
stitches; couching; 42.2 x 58.8 cm
(16½ x 23⅛ in.)

The Art Institute of Chicago,
Department of Textiles Collection,
1971.146[1]

Inscribed: *In memory of Mr. Nicholas
Winsor who died August 20 1797 Aged
30 / In memory of Mrs. Mary Bullock
who died ? 5 1802 aged 61*

Like sampler making (see cat. 27),
the practice of embroidering picto-
rial scenes on silk was an important
aspect of a young girl's education. The
death of George Washington in 1799
gave rise to a number of mourning or
memorial embroideries in honor of
the first president. This, in turn, led
to a growing trend for embroidered
mourning or memorial works dedi-
cated to departed family members,
which became a fashionable way to
express grief and remembrance.

In a Neoclassical landscape with
trees and a well-kept lawn, a monu-
ment with two urns commemorates
the deaths of Nicholas Winsor and
Mary Bullock. Inscriptions identify
the two individuals, while remnants of
writing on the monument indicate an
additional inscription that probably
expressed moral or religious senti-
ment. Weeping willows, a common
mourning motif, and two trumpeting
angels oversee the scene. Although
this sampler lacks the maker's name
and place, it was likely stitched
by either Mary or Louise (Louisa)
Winsor,[2] daughters of Mary Bullock
Winsor (November 13, 1767–February
4, 1816) and Nicholas Winsor (1767–
August 20, 1797). The identity of
the Mary Bullock in the inscription,
who died in 1802, is unknown; the
grandmother of the two girls Mary
Richmond Bullock (September 3,
1740–May 3, 1808) died in 1808, at the
age of sixty-seven, and their mother,
Mary Bullock Winsor, died in 1816.

Two other known members of the
Winsor family also created memorial
samplers. Frances (Fanny) Winsor
(1791–1883) (cousin of Mary and
Louise) was the daughter of Ira
(brother of Nicholas) and Patience
(sister of Mary Bullock) Winsor
(1767–1837). Fanny executed at least
two needlework pieces at Mary (Polly)
Balch's School in Rhode Island. The
description of one is reminiscent of
the Art Institute's memorial sam-
pler.[3] A distant relative of Mary and
Louise, Susan J. Winsor (1789–?),[4]
made a sampler in memory of Samuel
Thurber and Samuel Winsor. It is
extremely similar to the piece in the
Art Institute's collection, with the
same design of trumpeting angels and
weeping willows and the same treat-
ment of the lawn.[5]

The style of this piece and other
related works links them to Mary
Balch's School in Providence. Mary
Balch (1762–1831), also known as Polly,
began teaching in 1782 to help sup-
port her family. During her forty-five
years in education, several distinctive
styles of samplers and silk embroidery
evolved. The lack of mourning figures
and the inclusion of the trumpeting
angels on this sampler indicate that it
was among the earliest mourning and
memorial pieces made at the school;
the design element can be found in
several works dated to around 1800.[6]

Although they began as a tribute to
a national hero and then became
something of a trend, most mourning
and memorial samplers were the result
of formal instruction as part of a young
woman's education. This memorial
sampler, along with other types of
mourning art, is not a morbid tribute,
but rather a beautiful and sophisti-
cated expression of sentiment for
the dearly departed. Such works are
surviving testaments to the presence
of mortality in the everyday lives of
early-nineteenth-century Americans
and the influence it had on young
women. —*Odile Joassin*

1. This memorial sampler entered the
museum's collection around 1910 but was not
accessioned until 1971.

2. Joshua Bailey Richmond, *The Richmond
Family, 1594–1896* (J. B. Richmond, 1897),
p. 84. Records from the First Baptist Church
in Providence indicate that Mary married
Reverend Avery Brigs and later moved to
Hudson, New York, and Louise or Louisa
married Nathan C. Warren and moved to
Warren, Rhode Island. Henry Melville King,
*Historical Catalogue of the Members of the First
Baptist Church in Providence, Rhode Island*
(F. H. Townsend, 1908), p. 49.

3. Fanny Winsor's memorial sampler was in
the collection of Elizabeth R. Daniel as of
1967. Betty Ring, *Let Virtue Be a Guide to Thee:
Needlework in the Education of Rhode Island
Women, 1730–1830* (Rhode Island Historical
Society, 1983), p. 164.

4. Susan Jenckes Winsor was the half sister
of Nancy Winsor (1778–1850), who also
attended Mary Balch's School and is known
for her "ship" sampler. See Betty Ring, *Girlhood
Embroidery: American Samplers and Pictorial
Needleworks, 1650–1850*, vol. 1 (Alfred A. Knopf,
1993), pp. 178–79.

5. It is illustrated in *Magazine Antiques* (Sept.
1972), p. 511, and dated to c. 1808. It comes
from the Elizabeth R. Daniel Collection, Chapel
Hill, North Carolina.

6. Ring 1993 (note 4), pp. 179–87. The Art
Institute of Chicago's collection includes one
other example made at Mary Balch's School,
a sampler dated 1791 by Lucy Potter (1942.34).
See Ring 1983 (note 3), p. 170.

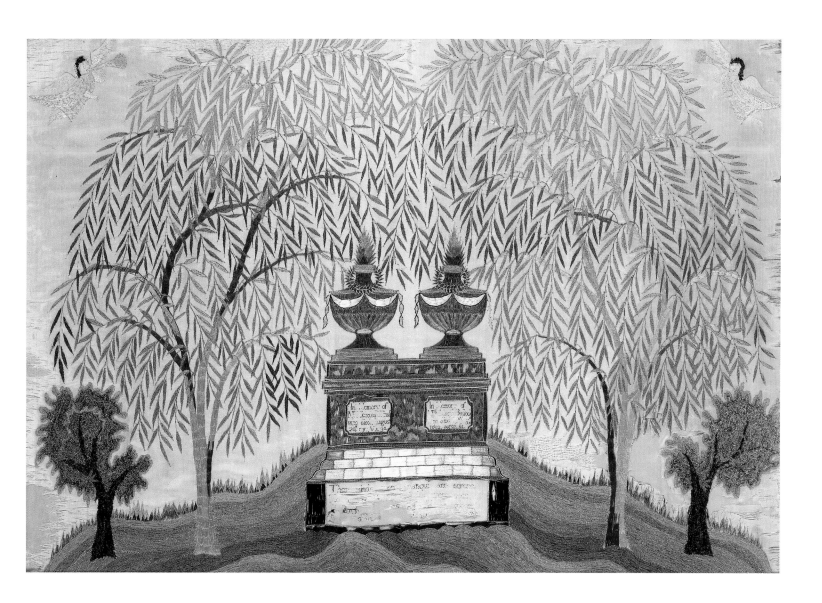

15

Possibly "Stimp" (active c. 1820)
Fireboard, c. 1820
From the John Moseley House,
Southbury, Connecticut
Oil on pine panel; 87 x 116.2 cm
(34¼ x 45¾ in.)

Quinn E. Delaney Fund; restricted
gift of the Antiquarian Society, Mrs.
Herbert A. Vance, Charles C. Haffner
III, and Jan Pavlovic, 2011.44

The fireplace and hearth served as the center of eighteenth- and early-nineteenth-century American homes. Indeed, before the invention of the portable stove at mid-century, the fireplace was used as both the stove and the central source of heat. In larger houses that had fireplaces in more than one room, fireplaces were often "dressed up" with paintings hung above the mantel and fireboards. Fireboards were especially common during the summer months, when they were utilized to beautify the gaping hole of the unused fireplace.

Fireboards, which were widely used in Europe in the eighteenth century, often feature floral and nature compositions, sometimes painted freehand and other times stenciled. They seem to have derived from the practice of putting a large pot of fresh greenery on an unused hearth, not only to beautify the space but also perhaps to eliminate some of the smell of wet ash. By the first quarter of the nineteenth century, fireboards were prevalent in the United States, and the same Neoclassical vocabulary of stylized trees, oak leaves, and meandering vines appears on American furniture and stenciled walls and floors. Itinerant artists who also painted coaches, shop signs, landscape decorations, and sometimes portraits painted most fireboards. Many of their designs were drawn from printed sources, contemporary engravings, or drawing manuals.[1] This fireboard is related to several stenciled walls found in nearby houses in Litchfield County and reportedly painted by a man called "Stimp"—perhaps one Caleb H. Stimpson, who paid taxes in the county where the paintings were found.[2] The lightness of the painting on this fireboard and the predominant use of primary colors lend an energized cheerfulness and nervous activity to the composition. Constructed of pegged and molded panels, it appears to have been made from half of a door. It is unusual in that it was painted not on a flat, planed surface, but on recessed panels that provide framing and depth for the delicately drawn trees and flowers. Also notable is the incorporation of gold leaf on the urn, which is overlaid on a cut-out engraving of "Hail Columbia." This tune, written in 1789 by Philip Phile for the inauguration of George Washington, remained an unofficial national anthem until 1931.

This fireboard was painted right around 1820, when John Moseley completed the construction of a house on Main Street North in Southbury, Connecticut. He owned the house, Oldfield, until his death in 1876.[3] It stayed in his family until 1902, when it passed into the Aston family, where it remained until 1965. (The two families were related.) In the 1959 volume *Homes of Old Woodbury: Tercentenary Celebration of Old Woodbury, Connecticut*, two painted fireboards were noted as still extant in the upper bedrooms of Oldfield. The Art Institute's fireboard probably left the house in 1965, the year that owner Albert Aston died. It was with Charles A. Carpenter in Shrewsbury, Massachusetts, in 1965 and by 1975 was in the collection of renowned folk art collectors Nina and Bertram Little. Nina Little illustrated it in her books *Country Arts in Early American Homes* (1975) and *Little by Little* (1984). The Littles died in 1993, and their home passed to Historic New England. Some of its contents were sold at Sotheby's the following year, including this fireboard.

1. Nina Fletcher Little, *Little by Little: Six Decades of Collecting American Decorative Arts* (E. P. Dutton, 1984), p. 92.

2. For other examples of Stimp's work, see Ann Eckert Brown, *American Wall Stenciling, 1790–1840* (University Press of New England, 2003), p. 50; and Janet Waring, *Early American Stencils on Walls and Furniture* (William R. Scott, 1937), p 44.

3. "Oldfield (1818)," Historic Buildings of Connecticut (2010), http://historicbuildingsct.com/?p=5116.

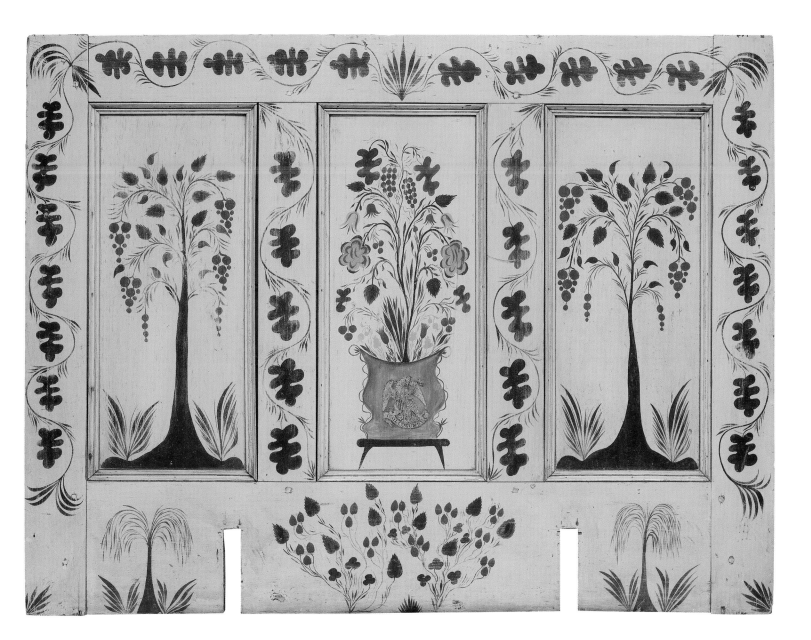

16

Artist unknown (English)
***Emblems for Royal Crown Lodge
No. 22***, 1810/15
Oil on panel; 63.5 x 80.7 cm
(25 x 31¾ in.)

Gift of the Estate of Edgar William and
Bernice Chrysler Garbisch, 1980.731

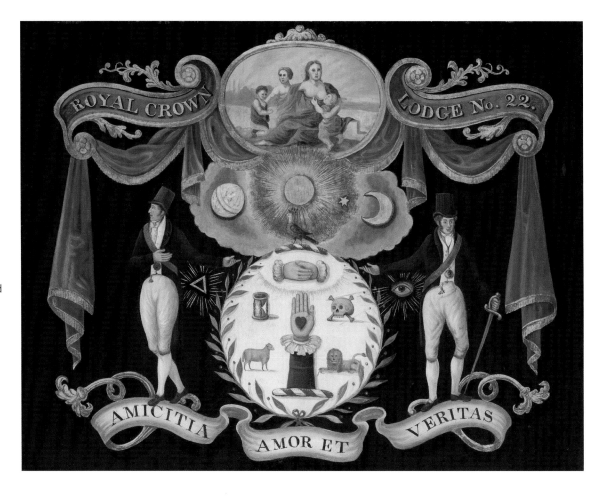

No doubt thought to be American at the time the Garbisches acquired it, this sign is actually English. It depicts an early coat of arms of a type used by the Odd Fellows lodges in the United Kingdom in the early nineteenth century and may have belonged to the Grand Lodge based in Sheffield.¹ Similar designs are found on English pottery dating from 1810–30, and many of the symbols associated with these fraternal organizations also appear on later household items, such as an American carpet in the collection of the Art Institute (fig. 1).

Active since the eighteenth century, the Odd Fellows was an organization that espoused universal brotherhood and charity and whose purpose was:

To Protect the Widows and Orphans; To bury the Dead: to Help Each other in Want; to Counsel each other in Difficulty; To Improve and Elevate the Character of Man; To Enlighten his Mind; to Enlarge the Sphere of his Affections; Whose Field of Action is Boundless as the Earth.²

Believing that God would take care of humanity in the next world, they

emphasized the moral responsibility of humans to care for one another in this world. Though lodges remained segregated by sex, female Odd Fellows organizations were eventually started in the nineteenth century. While English lodges were apparently integrated, American lodges were not. Although many prominent white American members were abolitionists, African Americans started their own lodges.

The first Odd Fellows lodge was founded in London, where such "friendly" societies were formed in taverns frequented by artisans. Many Odd Fellows organizations appeared throughout the United Kingdom, but eventually the largest and most dominant was the Manchester Unity of the Independent Order of Odd Fellows, formed in 1813.[3] Such societies allowed artisans and craftsmen to bond and care for one another as growing industrial capitalism made their labor redundant and widened economic divisions between classes.

The Odd Fellows shared many symbols with the Freemasons, an older society whose members were of a slightly higher social strata. Many of those emblems are incorporated into this painting. The symbols are a mixture of classical and biblical references. The all-seeing eye represents the omniscient gaze of God, the all-seeing judge; the sword alludes to the classical sign for justice; the shining sun and the globe both indicate patient impartiality and benevolence to all; the heart and hand denote openness, candor, and sincerity; and the skull and crossbones, the vanitas, remind us that we are of dust and to dust we shall return. Similarly, the hourglass suggests the fragile, temporal nature of life. The lamb symbolizes purity, as well as Christ, who takes away the sins of the world, while the lion represents courage. Both the lamb and the lion lie down together as symbols of harmony, as they do in the Old Testament book of Isaiah. Other biblical references include the moon and stars; the moon, reflecting the sun's truthful light, represents the smiles of friendship, love, and truth, the guiding philosophy of the Odd Fellows (which is written in Latin across the bottom of the painting). Usually, the moon is accompanied by the seven stars that symbolize the seven pillars of wisdom and the seven churches of Asia. The mother with a child at her breast alludes to the classical figure of Charity, as well as the Odd Fellows' protection of widows and orphans. The organization also used color symbolically: pinks, reds, greens, and blues symbolize the springtime of life, ardent love, nature, memory, and eternity.[4] Beautifully modeled and colored, this graceful sign would have hung in a place of honor in the lodge rooms—a reminder to all of the purposes and responsibilities of moral life.

1. Paul Eyre, Manchester Unity of the Independent Order of Odd Fellows, to Jack Whalen, Art Institute of Chicago, Nov. 5, 2010, Files of the Department of American Art, Art Institute of Chicago.

2. Theodore A. Ross, *Odd Fellowship: Its History and Manual* (M. W. Hazen Co., 1888), pp. 574–78; A. B. Grosh, *The Odd-Fellow's Manual* (H. C. Peck and T. Bliss, 1860), pp. 105–302.

3. William D. Moore, "Independent Order of Odd Fellows," in *Encyclopedia of American Folk Art,* ed. Gerard C. Wertkin (Routledge, 2004), p. 248.

4. Grosh (note 2).

Fig. 1 *Carpet* (detail), 1880/90. Wool, plain weave; double cloth; both selvages present; 194.7 x 137.2 cm (76⅝ x 54 in.). The Art Institute of Chicago, Dr. and Mrs. Magnus P. Urnes Endowment, 1992.424.

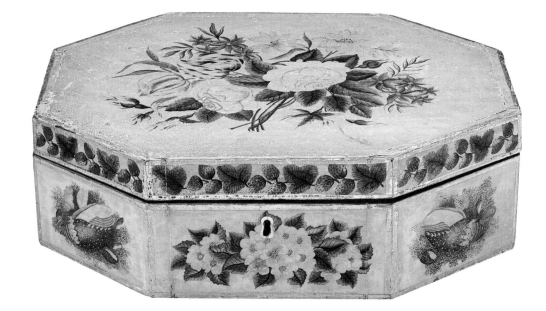

17

Trinket Box, c. 1820
Probably New England
Wood, paper, watercolor, and gilt
paper; 11.1 x 34.9 x 25.7 cm
(4⅜ x 13¾ x 10⅛ in.)

Elizabeth R. Vaughan Fund, 2007.80

Women had few artistic outlets during the early nineteenth century, but many young American women demonstrated their technical abilities in watercolor painting by decorating household furnishings. In addition to the ornamental arts of knitting, sewing, needlework, and drawing, watercolor painting was an indispensable skill for well-bred young ladies during this period. Many women attended small private academies (see fig. 1), where they learned to copy or stencil popular motifs found in prints, drawing manuals, and other book illustrations.

During the seventeenth century, trinket boxes became fashionable among the English upper classes as places to store objects of personal adornment. By the end of the eighteenth century, English and American elites used dressing glasses, while American middle-class women preserved the trinket box into the nineteenth century. Although some professional artists, like John Ritto Penniman (see cat. 10), ornamented furnishings, this box (and the majority that survive) was decorated by the woman who likely used it to hold chains, beads, buckles, ribbons, and other personal effects. Similar to other boxes from the period, it features an octagonal form, gilt edges (that create frames for each painted side), and ornaments derived from nature. Running along the edge of the lid is a delicate rendering of a repeating design of strawberries and a three-lobed leaf. The decorator also painted three different flower designs on the top, front, and back panels and six different shell designs on the remaining six sides, creating visual interest on all surfaces. The highly inventive variety of seashells, algae, and coral is rendered in crisp, expressive compositions, suggesting that the artist painted freely rather than with a stencil. This trinket box expresses the ornamental education and artistic ambitions of young school-age women in the United States during the early nineteenth century.

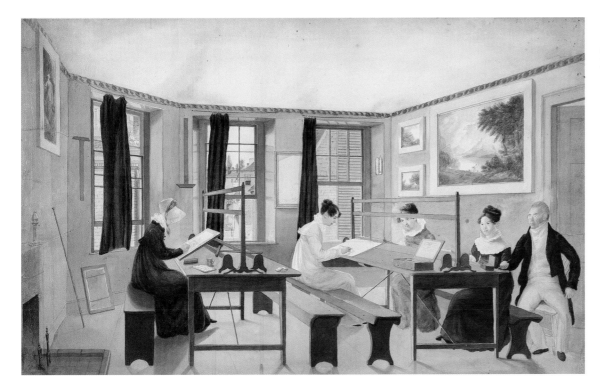

Fig. 1 Artist unknown (active 19th century). *The Drawing Class*, 1810/13. Watercolor over graphite on cream wove paper, laid down on cream board; 372 x 609 mm (14⅝ x 24 in.). The Art Institute of Chicago, gift of Emily Crane Chadbourne, 1951.202.

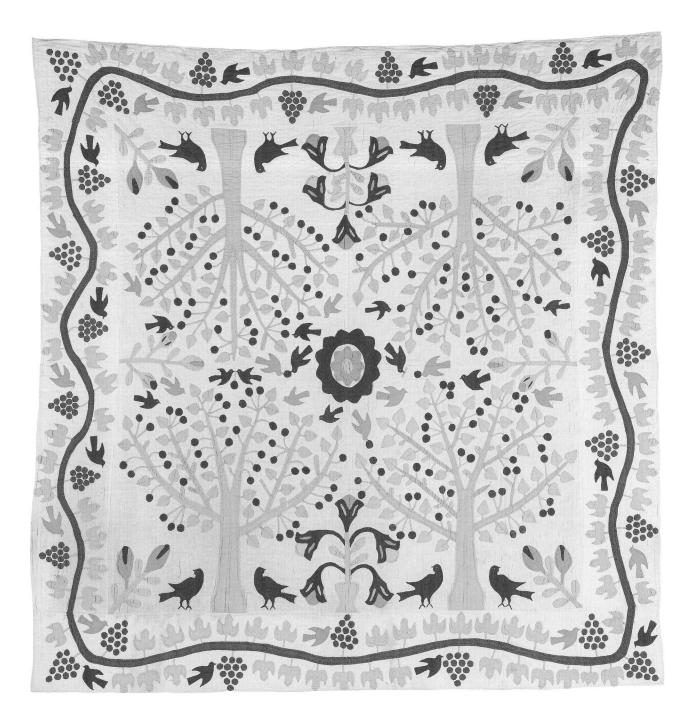

18

Bedcover (Cherry Trees and Robins Bride's Quilt), 1820/50
Cotton, plain weave; appliquéd with cotton, plain weaves; backed with cotton, plain weave; quilted; 193.2 x 192.7 cm (76⅛ x 75⅞ in.)

Gift of Emma B. Hodge, 1919.546

The popularity of appliquéd quilts during the nineteenth century, which peaked around the 1840s, resulted in part from the rising interest in album quilts and the increased availability of more affordable fabrics. Although appliquéd quilts often used repeated patterns laid out on a grid, appliqué also offered the maker the freedom and ability to create narrative and pictorial images not easily achieved with pieced quilts, which were often made from remnants of saved fabric.[1] This bedcover is identified as a bride's quilt, a significant part of a woman's dowry or hope chest. Though a hope chest included multiple quilts, the bride's quilt was the most ornate or finely quilted (see fig. 1).

The trees on this quilt reference traditional quilting patterns derived from the tree-of-life motif found on cotton *palampores* exported from India. These were often imported to the United States via England (where they were sometimes quilted) during the eighteenth and early nineteenth centuries.[2] Specifically produced for the European market and traditionally used as bedcovers or hangings, *palampores* featured a single winding flowering tree, reflecting the eighteenth-century taste for chinoiserie.[3] The appliqué tradition also offered a wide range of patterns that were disseminated among quilters; the "Cherry Trees and Robins" pattern may have been particularly popular, as a quilt of an extremely similar design from c. 1845 is in the Abby Aldrich Rockefeller Folk Art Center.[4] The Art Institute's bedcover was also published in the January 1922 issue of *The Ladies' Home Journal* with the indication that a pattern for it could be purchased;[5] at least two twentieth-century adaptations are known to exist.[6]

Although they were often anonymously made, utilitarian items, many quilts feature complex designs and highly skilled execution. The creation of quilts required careful planning of pattern and materials, and they represented an important outlet for female creative expression in early America.
—*Odile Joassin*

1. Elizabeth V. Warren and Sharon L. Eisenstat, *Glorious American Quilts: The Quilt Collection of the Museum of American Folk Art* (Penguin Studio, 1996), p. 36.

2. Robert Shaw, *American Quilts: The Democratic Art, 1780–2007* (Sterling Publishing Co., Inc., 2009), pp. 26–27.

3. John Guy, *Woven Cargoes: Indian Textiles in the East* (Thames and Hudson, 1998), pp. 106–08.

4. Barbara R. Luck, curator, Abby Aldrich Rockefeller Folk Art Center, to Christa C. Mayer-Thurman, curator, Department of Textiles, Art Institute of Chicago, July 6, 1984. Object file 1919.546, Files of the Department of Textiles, Art Institute of Chicago.

5. The last quarter of the nineteenth century saw a decline in the production of once-popular appliqué quilts, giving way to the craze for crazy quilts. It was not until the 1920s and 1930s that a resurgence in the making of appliquéd quilts based on historical types took place.

6. These examples are a quilt in the American Museum in Bath, England, made by Naomi Beckwith that is dated 1925–30 and another made by Maggie Smith that was exhibited at the 1933 Chicago Century of Progress International Exposition. See Laura Beresford and Katherine Hebert, *Classic Quilts from The American Museum in Britain* (Scala Publications, 2009), pp. 76–77.

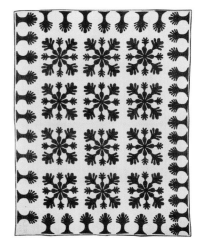

Fig. 1 *Bedcover (Bride's Quilt)*, 1861. Cotton, plain weave, pieced and quilted; appliquéd with cotton, plain weave, printed; backed with cotton, plain weave; 245.1 x 195.6 cm (96½ x 77 in.). The Art Institute of Chicago, gift of Emma B. Hodge, 1919.553.

19

Memorial Silhouette, c. 1845
Hand-cut tan wove paper, with pen and brown ink, tipped on tan wove paper with a glossy black coating; 248 x 311 mm (9¾ x 12¼ in.)

Gift of Elizabeth Winship, 1953.155

Inscribed at bottom: *Rhodes P. French / died Jan. 23rd 1831 / aged 49 years + 29 days / Rachel French died / Sept. 26th 1845, aged / 52 years, 2 months + 19 days*

George Washington's death in 1799 caused a proliferation of mourning imagery on lockets, miniatures, embroideries, and other such objects. Young ladies learned to craft mourning pictures in watercolor or needlework (see cat. 14), but this example was rendered with cut paper, referencing the American portrait silhouette tradition of the nineteenth century. Highly conventionalized mourning pictures were set within a pastoral landscape that included grieving female figures, willow trees, and urns, alluding to the culture of sentimentality—a nineteenth-century language that prized women's roles as emotional and spiritual caregivers in the home. Also related to sentimentality was the nineteenth-century acceptance of death, perhaps due to the era's high mortality rates. Mourning pictures memorialized death and also referenced Christianity and the Resurrection through their moral iconography.

In this silhouette, two figures—a grieving woman on the right and a woman pointing toward the heavens and carrying the anchor of hope on the left—flank the central Neoclassical monument, on which an urn rests. A weeping willow and another tree, likely an elm, surround the women; next to the elm, a robed man stands on symbols of death—a skull and crossbones and an hourglass—and carries a cross that points upward. Framing the composition are two tall triumphal columns decorated with spiraling garlands upon which two classical Virtues—Justice armed with scales and her sword, and Wisdom with a book and sheaf—precariously balance on urns. Held by trumpeting angels, the central epitaph in the garlanded orb reads: "Thrice happy they / whom early death doth take / From all the trobles [*sic*] / of a wretched world, / whom their Redeemer / doth victorious make, / under the Christian flag / in Heav'n unfurl'd." Delicate pinpricking throughout the composition (on urns, angel wings, and the cornucopia, for example) created decorative patterns and an allusion of depth.

The central monument of the silhouette lists the dearly departed Rhodes P. and Rachel French. Very little is known about the Frenches, who lived in New York City.[1] Frequently, mourning pictures were amended when another family member died, but this example was likely completed after both parties passed away, given the cut-paper treatment and the fact that the poetic verse uses the plural "they." It was made just as mourning pictures began to decline in popularity.

1. In the 1808 *Longworth's American Almanac, New York Register, and City Directory*, Rhodes French is listed as living at 342 Water St. (in lower Manhattan). In the 1842 and 1843 *New York City Directory*, Rachel French is listed as "widow of Rhodes," living at 147 Varick St. (also in lower Manhattan). Rhodes's profession is not listed.

20

William Bonnell (1804–1865)
J. Ellis Bonham, March 5, 1825
William Bonham, March 4, 1825
Mrs. William Bonham (Ann Warford),
March 6, 1825
Oil on panel; 30.5 x 24.9 cm
(12 x 9 ¹³⁄₁₆ in.)

Estate of Edgar William and Bernice
Chrysler Garbisch, 1980.741, 739–40

Inscribed on reverse (1980.741):
William Bonnell / Pinxt / March 5th 1825

Inscribed on reverse (1980.739):
*William Bonnell / Pin / March 4th / 1825
/ Portrait of Wm Bonham / Painted at
the age of 38 years*

Inscribed on reverse (1980.740):
William Bonnell / Pinxt / March 6th 1825

William Bonnell lived and died in Clinton, New Jersey. His grandfather Abraham was a Revolutionary War colonel and operated Bonnell Tavern, which remained in the family for generations. About thirty extant paintings, thirteen of which are on panel, record Bonnell's career as a portrait painter. In 1825 he made seven portraits of his Hunterdon County neighbors. Portraits of three members of the Bonham family vary widely in style from the other portraits Bonnell painted that year. The panels are smaller in scale than his other portraits; figures occupy little of the composition's space; heads are disproportionate to bodies, with large eyes and small hands; and backgrounds are dark, with little contrast to the subjects, who seem surrounded by unusual patches of light. The naive qualities of the art of this inexperienced painter demonstrate affinities with the purposeful disproportions, lack of perspective, and sparseness of modern art.

Yet Bonnell captured the earnestness of this dutiful Presbyterian family through their large, luminous, slightly anxious eyes. Each sitter holds an attribute: Mrs. Bonham her embroidery, Mr. Bonham a carpenter's plane, and young Ellis a book. So different are these portraits from others done even weeks later by Bonnell that some historians believe the artist must have profited by studying the works of other itinerant portraitists in the area. Some have noted affinities between Bonnell's later work and the portraits of Ammi Phillips (see cat. 11), but there

is no proof that the two knew each other.[1] These three pictures differ from the rest of Bonnell's oeuvre because they were painted quickly on three consecutive days. Their small scale may reflect the modest circumstances of Mr. Bonham, which affected his ability to purchase portraits of his family. Made for household use, they refer back to the intimacy of the eighteenth-century miniature tradition.[2]

Little is known about the life of William Bonham. Inventories of his estate include the tools of a wheelwright and woodworker, such as the plane in his portrait. He was born around 1787 and died in 1872. Bonham and Ann Warford, his second wife, married in March 1819. J. Ellis was the only child from his father's first marriage and was born in 1816, making

Fig. 1 J. Ellis Bonham, c. 1840. From Olive Barrick Rowland, *An Ancestral Chart and Handbook* (Garrett and Massie, 1935), p. 121.

him a precocious nine-year-old in his portrait. He went on to a distinguished legal career and was politically active in Carlisle, Cumberland County, Pennsylvania (see fig. 1). He was highly thought of as among the ablest lawyers admitted to the bar but was defeated for a seat in Congress. Ellis, who was described as having a taste for literature, owned a large library, gave effective speeches, was small in size and delicately formed, had light hair and a light complexion, and was so fragile in health that he died at age thirty-nine, in March 1855, most likely of tuberculosis.[3]

The three portraits of the Bonham family came to the Art Institute in 1980 from the estate of the great folk art collectors Edgar William and Bernice Chrysler Garbisch, who began acquiring "primitive" paintings in 1944. Believing that this art merited wider appreciation, they gave works to museums and organized traveling exhibitions of the over 2,500 pieces in their collection.

1. Julie Aronson, "William Bonnell," in Deborah Chotner, *American Naive Paintings* (National Gallery of Art/Cambridge University Press, 1992), p. 25; and Jean Lipman and Alice Winchester, *Primitive Painters in America, 1750–1950* (Dodd, Mead and Co., 1950), p. 169.

2. Anne Kennedy, "William Bonnell (1804–1865)" (MA thesis, University of Manchester, 2010), p. 31.

3. *History of Cumberland and Adams Counties, Pennsylvania* (Warner, Beer, and Co., 1886), pp. 166–67.

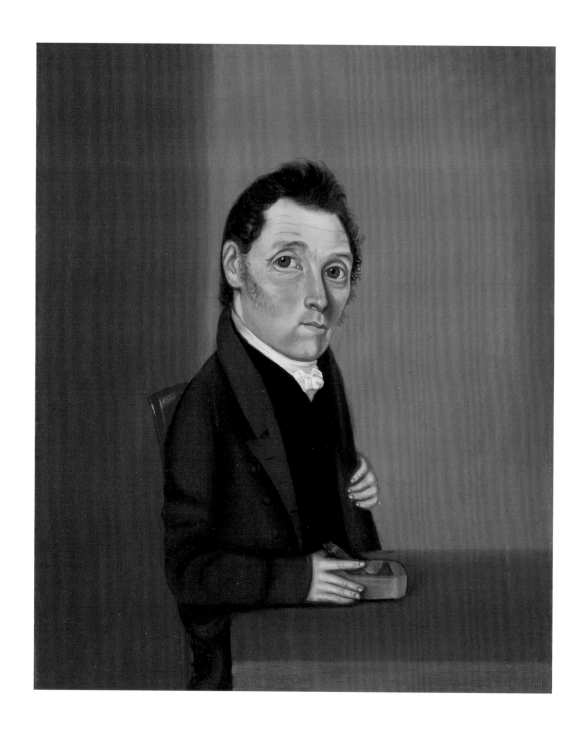

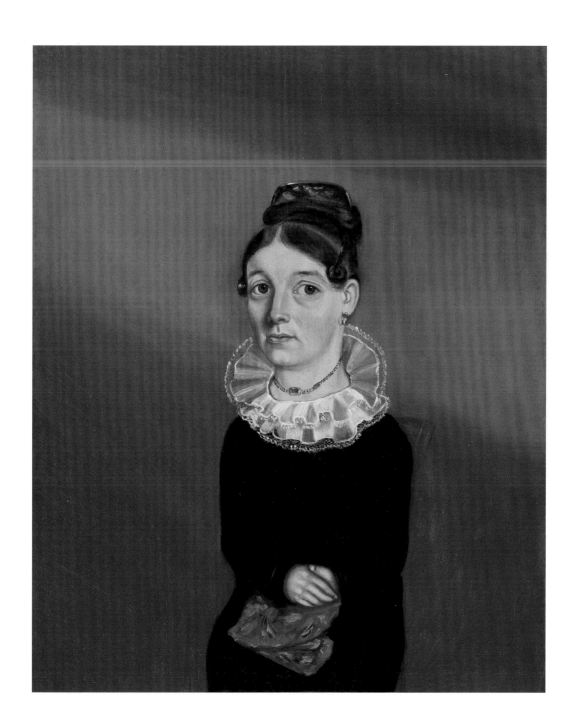

21

Weather Vane, 1800/60
Pennsylvania
Iron; 131.8 x 71.1 x 2.5 cm
(51⅞ x 28 x 1 in.)

Bequest of Elizabeth R. Vaughan,
1952.549

Before the advent of modern mecha-
nized devices, weather vanes were an
important source of information on
wind and shifting weather condi-
tions. Closely related to whirligigs (see
cat. 52), weather vanes, which were
intended to be viewed from a distance,
could be fashioned into three-
dimensional forms or silhouettes.
This silhouetted rooster weather vane
was purchased from Edith Halpert's
Downtown Gallery by the Art Institute
in November 1952 with funds estab-
lished by museum patron Elizabeth
Vaughan. Halpert's notes about this
object indicate that it was removed
from a farmhouse in West Chester,
Pennsylvania.[1] She also observed that
"in its simplified design, and balance
of forms, it is closely allied with the

current direction in modern sculp-
ture," thus legitimizing the abstracted
folk art weather vane as an art object,
which was part of Halpert's agenda as
a dealer in both of these arenas.

The rooster was an exceedingly
popular subject for weather vanes.
Depictions of other animals were also
pervasive, including racehorses, which
were venerated in the nineteenth
century (see cat. 44). Eventually,
handcrafted weather vanes—such
as the rooster, which was cut from a
flat sheet of iron—were replaced by
commercially produced ones, such
as those made by A. L. Jewell and
Co. (see fig. 1). Situated in Waltham,
Massachusetts, Alvin L. Jewell's firm
was innovative in its manufacturing
and advertising methods, and helped
to change the American weather-vane
industry through molding processes
and mass production, rendering older
weather vanes virtually obsolete.

1. Downtown Gallery Records, 1824–1974
bulk 1926–1969, series 3.1 (American Folk
Art Gallery Notebooks. Sculpture, Metal and
Wood—Weather Vanes—Birds. [Reel 5563,
Frames 640–761]). Archives of American Art,
Smithsonian Institution.

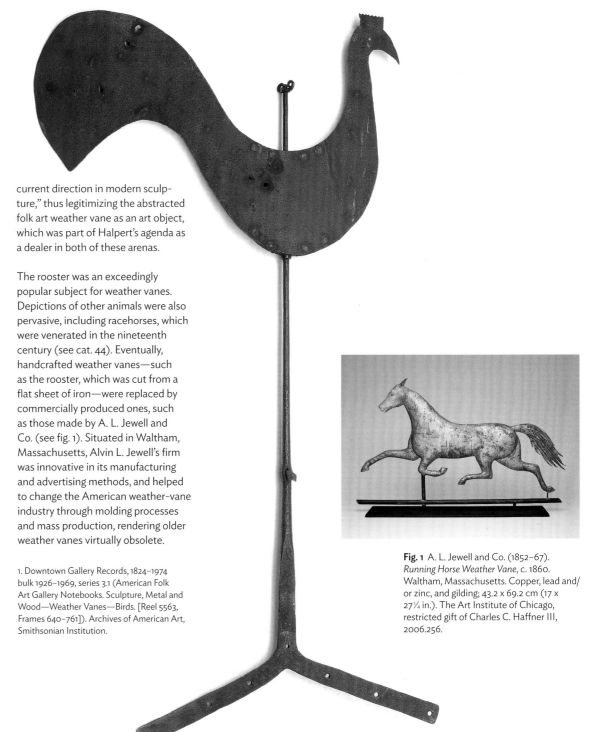

Fig. 1 A. L. Jewell and Co. (1852–67).
Running Horse Weather Vane, c. 1860.
Waltham, Massachusetts. Copper, lead and/
or zinc, and gilding; 43.2 x 69.2 cm (17 x
27¼ in.). The Art Institute of Chicago,
restricted gift of Charles C. Haffner III,
2006.256.

22

Face Flask, 1820/40
Probably New England
Salt-glazed stoneware; 12.1 x 8.9 x
12.7 cm (4¾ x 3½ x 5 in.)

Wilson L. Mead Fund; Stanley and
Polly Stone Endowment, 2007.462

Until its acquisition by the Art
Institute, this face flask was in the
possession of the descendents of
Samuel Parker.[1] Parker was born in
Ashfield, Massachusetts, in 1779 and
later graduated from Williams College
(1806) and Andover Theological
Seminary (1810).[2] Ordained as a
Congregational minister in 1812, he
initially served as a missionary in
western New York before becom-
ing the leader of the Congregational
Church in Massachusetts and New
York. During 1835 Parker answered the
call of missionary work in the Oregon
Territory; he penned a journal during
the trip and lectured widely on the
topic of his Western experiences.[3] His
travels provided him the expertise to
encourage settlement of the West

and advise the government on the
route of the transcontinental railroad.
Although we do not know how or
where Parker carried this flask, it is
tempting to speculate that it ventured
westward with him.

This pocket flask would have held
shot or powder, important for Parker,
who wrote that it was imperative to
"have a good supply of powder and
balls" in preparation for attacks.[4] It
is in the form of a face, reflecting
the nineteenth-century interest in
depicting the human face on pottery
(see cat. 31). The maker rendered
the facial features through modeling,
incising, and glazing; the eyes, nose,
mouth, and one ear were modeled,
and the hair and other ear were incised
(providing a flat surface for the flask
to lay on). A cobalt glaze was spar-
ingly utilized to highlight the pupils,
eyebrows, and mouth. Although the
flask's maker is unknown, it might have
been made in Massachusetts, where
Parker was raised.[5] However, it could
also have been made in Connecticut,
as some other face flasks have sur-
faced there, and Parker could have
traveled through Connecticut to arrive
in western New York.[6]

1. According to Gary and Diana Stradling, the
flask was kept in a box with other souvenirs of
Parker's Oregon trip, all of which aid in identi-
fying him as the owner of the flask.

2. Biographical information on Samuel Parker
may be found in James Grant Wilson, ed.,
Appleton's Cyclopedia of American Biography,
vol. 4 (D. Appleton and Company, 1888),
p. 654.

3. His diary was published in 1838. See Samuel
Parker, *Journal of an Exploring Tour beyond the
Rocky Mountains* (published by the author,
1838).

4. Ibid., p. 57.

5. The face flask resembles an 1833 pitcher
published in Diana and Gary Stradling, eds.,
The Art of the Potter: Redware and Stoneware
(Main Street/Universe Books, 1977), p. 96.

6. Gary and Diana Stradling identified other
flasks of this type that have surfaced in
Connecticut, suggesting that this piece could
have been made in Stonington.

23

Edward William Farrar (1807 [?]–1845)
Jar, c. 1830
Middlebury, Vermont
Redware; h. 23.9 cm (9 ⅜ in.);
diam. 21.3 cm (8 ⅜ in.)

Juli and David Grainger Fund, 2007.219

Stamped: *E W Farrar*

This exceptional example of early Vermont redware is at once exuberant and delicately rendered. The vessel has wonderfully elaborate decoration, with stamped bands of geometric designs running along the upper half of the vessel that contrast with the curves of the green glazed swags and the ruffles around the neck of the jar. Currently, there is one other extant jar stamped by "E W Farrar" with similar bands and graphic glazing.[1]

Edward Farrar was part of a family of Vermont potters, although his lineage is not clear. The son of Reverend Stephen Farrar of New Ipswich, New Hampshire, Caleb Farrar was born in June 1780, married Sarah Parker on March 15, 1804, and lived in Middlebury, Vermont. Although other members of the Farrar family also

produced stoneware, Caleb exclusively made redware in Middlebury beginning around 1812.[2] He owned a pottery until 1850, when he sold it to James Mitchell.[3] According to *Memoir of the Farrar Family*, Caleb and Sarah Farrar had five children: Eveline, Clarissa, Henry Brown, Martha, and George.[4] Interestingly, Edward William, the presumed potter of this vessel, is not named as one of Caleb's children. In the 1820 census, Caleb was listed as head of a household with three white females under sixteen (his daughters, Eveline, Clarissa, and Martha), two white males under sixteen (his sons, Henry and George), and two other males above the age of twenty-six. The census also lists two men "engaged in manufactures." Further complicating the identity of E. W. Farrar, whose stamp appears on the jar, is the familial association between Edward and Caleb. Although Edward does not appear to be the son of Caleb, he was listed alongside Henry, Loisa (Eveline?), and Clarissa as having been baptized at the Church of Christ, Middlebury, on October 4, 1818, with Caleb and his wife as sponsors.[5] Further research into the Farrar family of potters and Vermont redware needs to be undertaken to uncover the identity of Edward.[6]

1. It is in the Vermont Historical Society (1957.1.28).

2. This is first mentioned in Edwin Atlee Barber, *Pottery and Porcelain of the United States: An Historical Review of American Ceramic Art from the Earliest Times to the Present Day* (G. P. Putnam's Sons, 1893), p. 438.

3. Lura Woodside Watkins, *Early New England Potters and Their Wares* (Harvard University Press, 1950), p. 139.

4. Timothy Farrar, *Memoir of the Farrar Family* (T. Prince, 1853), p. 39.

5. Thanks to Diana and Gary Stradling, who provided the author with a copy of church records, "Formation of the Church of Christ, Middlebury, Vermont, September 5, 1790."

6. There was an Edward William Farrar born on Apr. 15, 1817, but he was part of the Maine branch of the Farrar family and spent his life there. There was also an Edward Warren Farrar, born on Nov. 14, 1822, but he graduated from Harvard Law School and lived in Keene, New Hampshire.

24

George Muk (c. 1813–after 1850)
Saleratus Jar, 1848
Bladensburg, Maryland
Salt-glazed stoneware; h. 16.8 cm
(6⅝ in.); diam. 12.7 cm (5 in.)

Gift of Mahlon Moulds, 1920.435

Inscribed: *Salaratus [sic] Jar. Mrs.
Hannah Craig. Made by George Muk,
Bladensbur [sic], Dec. the 1st 1848.*

Best known as the site of a battle during the War of 1812, Bladensburg, Maryland, was a crossroads for routes to Washington, D.C., Baltimore, Philadelphia, and Annapolis. Located on the Anacostia River, its role as a seaport vanished as the river silted up, preventing ships from entering the town.[1] As John Finch's *Travels in the United States of America and Canada* (1833) indicated, Bladensburg's foundation was characterized by red sandstone, which was reinforced by the exposed red soil in nearby Washington, D.C. Although red earthenware clays were abundant in various Maryland counties, there

were also clays suitable for stoneware production, including in Prince George's County, where Bladensburg is located.[2] Missing its cover, this ovoid stoneware jar has an unusual reddish hue due to the soil composition near Bladensburg. Ornamenting the jar is a boldly graphic incised birds-on-vine motif in cobalt oxide.

Although the potter signed his name "Muk," this vessel may have been thrown and decorated by George Muck, who appears in the 1850 census in Frederick County, Maryland, as

a thirty-seven-year-old living with several family members.[3] Muk made this vessel for Mrs. Hannah Craig in Bladensburg, Maryland, on December 1, 1848. As suggested in the inscription, Craig would have used her utilitarian stoneware jar for the storage of saleratus. In Maryland cookery, saleratus was used to make buckwheat cakes, cream cakes, muffins, doughnuts, composition cakes, coffee cakes, gingerbread, and saleratus cakes or biscuits.[4] Saleratus was the American name given to an alkali-only rising agent composed of sodium bicarbonate; it

required an acid (sour milk) in order to generate carbon dioxide to form bubbles in the dough.[5] During the nineteenth century, many Americans consumed the popular saleratus biscuit, which incorporates a small amount of the powder with sour milk, alongside flour and butter.[6]

1. John F. Biddle, "Bladensburg: An Early Trade Center," in *Records of the Columbia Historical Society, Washington D.C.*, vols. 53/56 (Historical Society of Washington, D.C., 1953/56), pp. 309–26.

2. *Maryland Geological Survey*, vol. 4 (Johns Hopkins Press, 1902), pp. 483–85.

3. John Ramsay listed George Muk as a potter from Bladensburg, Prince George's County, Maryland, based on this 1848 jar, although he called it redware. Ramsay provided no further information about Muk. John Ramsay, *American Potters and Pottery* (Hale, Cushman and Flint, 1939), p. 165.

4. M. L. Tyson, *The Queen of the Kitchen: A Collection of "Old Maryland" Family Receipts for Cooking* (T. B. Peterson and Bros., 1874).

5. Alan Davidson, *The Penguin Companion to Food* (Penguin Reference, 2002), p. 59.

6. Elizabeth E. Lea, *Domestic Cookery, Useful Receipts, and Hints to Young Housekeepers*, 10th ed. (Cushings and Bailey, 1859), p. 69.

25

Miss Gorham's Seminary, 1820/30
Watercolor with pen and black and brown ink, over graphite, on pieced tan wove paper; 485 x 432 mm (19⅛ x 17 in.)

Gift of Emily Crane Chadbourne, 1953.21

Previously denied equal educational opportunities, middle-class American women began to attend school in the 1820s as part of the new republican society. During the antebellum period, the success of the nation's future was tied to a flourishing home and family life, spheres of feminine influence. The growing female seminary movement during these years reflected the earnest regard for women's child-rearing and educational responsibilities in the home. Women's seminary curriculum was based on classical education, including Latin, Greek, mathematics, and science, as well as traditional female-oriented "ornamental" education (see cat. 17).

In this delicately painted watercolor, young seminary women of varied ages clad in white walking dresses stand outside Miss Gorham's Seminary.[1] Set within a rural landscape, the building likely originated as a home and was altered over time. A horse and carriage trotting up the road complement the bucolic rural setting. The young girl who painted the scene also penned a sentimental poem surrounding the elegantly calligraphed "Miss Gorham's Seminary." This watercolor was created by a young woman enrolled at the seminary; the illegible inscription in the border notes that it is someone's "piece." Illustrating some of the tenets of an "ornamental" education—including watercolor painting, calligraphy, and poetry writing—this object may have been an exercise toward the completion of a schoolgirl's education. Articulating the maker's dedication to education, the poem begins: "Behold the spot where early years / Were mingled with young hopes & fears, / Where long I toiled to win the prize, / What science hold [*sic*] before my eyes." It concludes: "It cannot be those days have fled, / Like dews on early flowers shed, / Yet shall their influence long impart, / Its richest treasures to my heart." Although the watercolor is not signed or dated, it was likely rendered in the 1820s, as suggested by the style of walking dresses. The small seminary also resembles a boarding school, as opposed to later seminaries, which were full-scale institutional buildings by the mid-nineteenth century.

Although there was a female seminary in Gorham, Maine, this watercolor does not depict that building, which

Fig. 1 Mary Jane Wynkoop (1810–1887). Frontispiece of *Poetry and Prose*, 1824. Special Collections, Dibner Library of the History of Science and Technology, Smithsonian Institution Libraries.

was a much larger four-story institution dedicated in 1837.[2] However, it may show the female seminary located in Elizabeth, New Jersey. Although not by the same hand, a volume of work by fellow New Jersey seminary student Mary Jane Wynkoop—which includes a selection of poems, some prose, riddles, and puzzles—references Miss Gorham's School (fig. 1).[3] Little is known about Wynkoop, who was born on January 20, 1810, married Henry Hinsdale Reynolds on October 1, 1834, and died on March 4, 1887, in Kingston, New York.[4] Miss Gorham's School, which was considered a boarding school, was located in Elizabethtown (the town's official name until 1855 and the name used on Wynkoop's title page) from the years 1813 to 1835; the town was rural until the late nineteenth century.[5] Although a photograph or illustration of the seminary has not yet surfaced, this watercolor suggests that the school building was of the same scale as the other boarding schools in Elizabeth. Thus, perhaps it is this Miss Gorham's Seminary that is illustrated in the Art Institute's watercolor.

1. Old Sturbridge Village has a watercolor depicting the same "Miss Gorham's Seminary" (20.5.104). In a Sept. 1, 2010, e-mail, Curator Tom Kelleher said the institution had not yet identified the location of the seminary.

2. A photograph of the seminary is illustrated in Hugh D. McLellan, *History of Gorham, Maine* (Smith and Sale, 1903), between pp. 240 and 241.

3. The volume, MSS 1643B, is located in Special Collections, Dibner Library of the History of Science and Technology, Smithsonian Institution Libraries. The author would like to thank Kirsten van der Veen, Dibner Library, for her assistance.

4. Richard Wynkoop, *Wynkoop Genealogy in the United States of America*, 3rd ed. (Knickerbocker Press, 1904), p. 115.

5. *The City of Elizabeth, New Jersey, Illustrated: Showing Its Leading Characteristics, Its Attractions as a Place of Residence and Its Unsurpassed Advantages as a Location for Manufacturing Industries* (Elizabeth Daily Journal, 1889), p. 106.

26

Jonas Welch Holman (1805–1873)
Woman with a Book, 1827/30
Man with a Pen, 1827/30
Oil on yellow poplar panel;
70.8 x 54.6 cm (27 7/8 x 21 1/2 in.)

Gift of Robert Allerton, 1946.393–94

Jonas Holman worked as a portrait painter, writer, doctor, and preacher. During the Second Great Awakening of the early nineteenth century, he supported himself through a number of vocations as he traveled among Baptist congregations.[1] Initially, he moved throughout his native Maine and southwestern New Brunswick, Canada, but by 1827 he had made his way to Philadelphia, where he was employed as both a pastor and a portraitist. While there he painted seven known portraits, among them *Woman with a Book* and *Man with a Pen*. He performed several marriages and, in the fall of 1827, traveled to Baltimore for a three-month stay. By 1833 he had moved to Boston and was pursuing a medical degree at Harvard University. He remained in Massachusetts until around 1845, lived briefly in Maine (1848), and then moved to New York City, where he remained until 1860. His career as a physician was brief, and he listed his occupation as a pastor during the 1850s.

These two works are closely related to another pair of portraits executed during his Philadelphia sojourn; both pairs were originally found in Philadelphia.[2] In these paintings, Holman substituted a brilliant, tasseled curtain for a plain background. He showed his sitters in painted "fancy" chairs, with broad, Greek Revival crest rails, similar to painted furniture made in Philadelphia and Baltimore. Like Ammi Phillips, Holman used props that pointed to the sitters' erudition. He concentrated on the details of his sitters' costumes, showing women with rings and earrings and men with stickpins fastened to cravats. His attention to the pierced quality of lace created positive and negative spatial counterparts in an otherwise flattened but realistic depiction. As in his other portraits, almond-shaped eyes—and, in the case of *Man with a Pen*, even an almond-shaped ear—predominate. These characteristics support the attribution of these portraits to Holman, even though they are unsigned.

1. Caroline M. Riley, "Portrait of a Painter: The Double-Sided Life and Works of Jonas W. Holman (1805–1873)" (MA thesis, University of Delaware, 2006).

2. This account comes from the records of the Downtown Gallery (1926–1969 Series 3.1: American Folk Art Gallery Notebooks. Oil Paintings, Portraits—Adult Pairs and Family Groups [Reel 5559, Frames 8-75]. Archives of American Art, online collections). At the time, the portraits were called *Man in Hitchcock Chair* and *Woman in Hitchcock Chair*. The second pair of related portraits was once owned by Juliana Force and is now in a private collection. The Art Institute's portraits were sold by the Downtown Gallery to Robert Allerton in 1938.

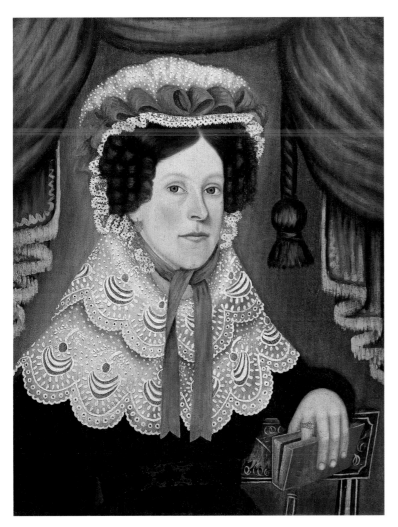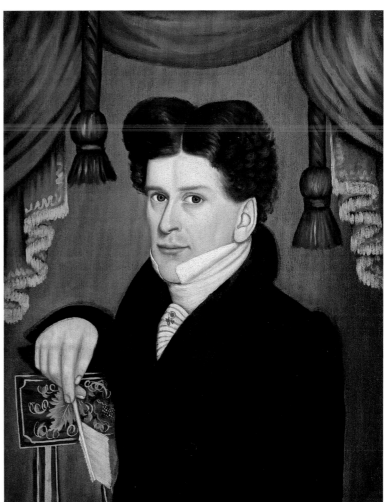

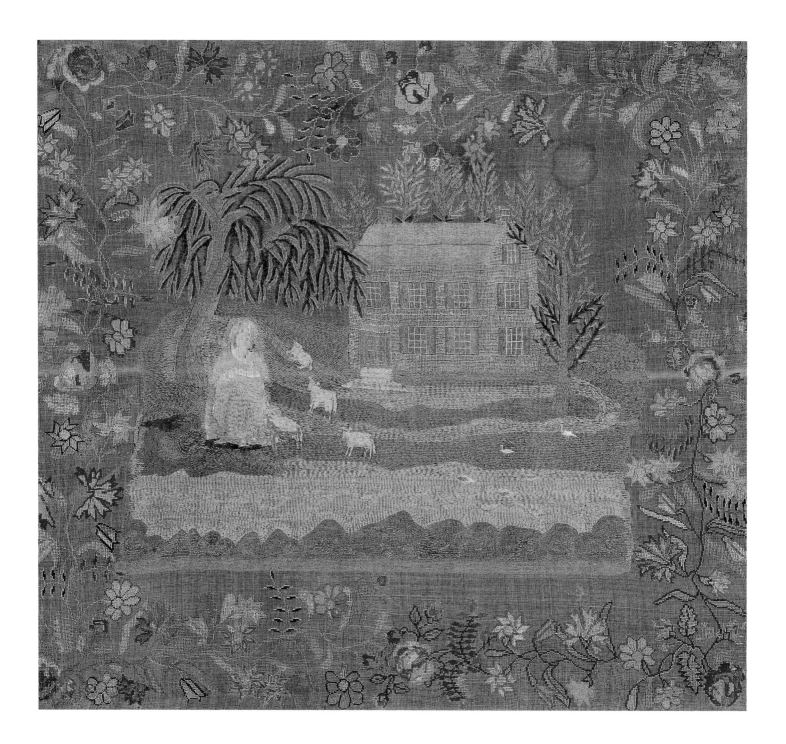

27

Sampler, 1820s
Baltimore, Maryland
Linen, plain weave; appliquéd with
silk, warp-float faced 5:1 satin weave;
painted; embroidered with silk, silk
chenille, and wool in cross, overcast,
satin, split, stem, and tent stitches;
88 x 97.8 cm (34⅝ x 38½ in.)

Gift of Robert Allerton, 1926.488

During the early nineteenth century, Baltimore and its environs experienced substantial growth and prosperity. As the city grew, so too did the status and personal importance of its inhabitants and, in turn, the demand for teachers and educational institutions. Girls' education included the execution of samplers and other needlework, which was an integral part of formal schooling. Needlework and sampler making not only functioned as an outlet for young girls to practice their stitches and learn the alphabet, but also served as a way to express their moral fiber. The execution and subsequent display of a finished work demonstrated the maker's patience, gentility, and any number of other qualities that were valued in accomplished young women of the period.

From around 1798 through the 1820s, it was fashionable to include the depiction of a particular style of brick building in samplers made in Baltimore. This piece exhibits a number of similarities to a group of samplers identified by Betty Ring as "Building Samplers of Baltimore."[1] Many aspects of this sampler closely resemble those found in a subcategory of picturesque Baltimore building samplers from the 1820s designated as "Busy Yard Samplers" by Gloria Seaman Allen.[2] The "Busy Yard Samplers" are further broken down into two different groups; the group that this example belongs to includes several distinctive motifs: a two- or three-bay brick house, a lawn filled with people and animals, and a floral border. This subgroup is composed of samplers made by Mary Davis (see fig. 1),[3] Eliza Ann Suter,[4] Ann Elizabeth Tuxworth,[5] and Frances A. McCubbin.[6] The Art Institute's sampler has a number of similarities to the other pieces in the group: the three-bay gabled Federal-style brick house with blue shutters, the expanse of lawn with an idyllic scene of a shepherdess tending to her flock of sheep, the floral and vine border surrounding the scene, and the unusually large format of the piece.

One very distinctive feature of this sampler is the stream flowing across the yard; this replaces the fence usually found in the foreground of the "Busy Yard Samplers." Additionally, unlike the trees in the other works of the subgroup, the tree under which the shepherdess sits resembles an amalgamation of a willow and palm tree, and this sampler also includes a cluster of trees surrounding the house. This piece may be part of another related subgroup or simply a variation resulting from the maker's creativity in the depiction of the foreground. Overall, it evokes a sense of refinement and sophistication associated with the development of an urban, civilized environment. —*Odile Joassin*

1. Betty Ring, *Girlhood Embroidery: American Samplers and Pictorial Needlework, 1650–1850*, vol. 2 (Alfred A. Knopf, Inc., 1993), pp. 506–12.

2. Certain styles or motifs became associated with a specific region or linked to a specific academy, schoolmistress, or private teacher. For a discussion of teachers advertising in Baltimore, see Gloria Seaman Allen, *A Maryland Sampling: Girlhood Embroidery, 1738–1860* (Maryland Historical Society, 2007), pp. 195–96, 211–13; and Mary Jeane Edmonds, *Samplers and Samplemaker, An American Schoolgirl Art, 1700–1850* (Rizzoli International Publications, Inc., 1991), pp. 133–41.

3. This sampler is inscribed, "Mary Davis Baltimore March the 13th 1826." Ring also linked this piece to one in her collection made by Elizabeth Ireland and dated to 1819. The sampler included the name of the schoolmistress Mrs. Lyman. Ring proposed Lyman as the possible originator for the style featured in the group of Baltimore samplers that includes the Davis piece. This is based on the similarity of the floral borders in Ireland's and Davis's samplers, which are somewhat similar to that of the Art Institute's piece. See Ring (note 1), pp. 510, 512, fig. 567.

4. This 1826 sampler, in the Allen W. Kent Collection, is inscribed, "Eliza Ann Suter Baltimore May the 1826." See Allen (note 2), p. 213, fig. 12-12.

5. This 1821 sampler, in a private collection, is inscribed, "Ann Elizabeth Worke Done in / Her ninth Year of Her Age / Baltimore December / 3. 1821." See Allen (note 2), p. 212, fig. 12-11.

6. This unfinished and undated piece is in the collection of the Maryland Historical Society.

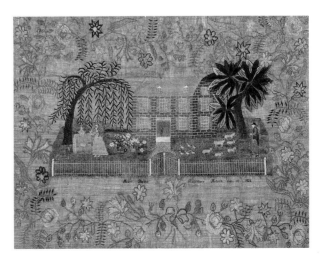

Fig. 1 Mary Davis. *Embroidered Sampler*, 1826. Baltimore, Maryland. Silk, chenille, and paint on linen; 76.2 x 97.8 cm (30 x 38½ in.). The Metropolitan Museum of Art, gift of Barbara Schiff Sinauer, 1984.331.10.

28

Erastus Salisbury Field (1805–1900)
Woman with a Green Book (Louisa Gallond Cook), 1838
Oil on canvas; 88.9 x 74.3 cm
(35 x 29¼ in.)

Gift of the Estate of Edgar William and Bernice Chrysler Garbisch, 1980.746

Erastus Salisbury Field and his twin sister, Salome, were born in Leverett, a small western Massachusetts hill town. We can only imagine what his early exposure to art might have been, but he showed a talent for likenesses and at nineteen moved to New York City, where he studied with Samuel F. B. Morse. His education there was terminated after just a year, when Morse's wife died in 1825. Field returned to Leverett, to a perhaps less-demanding clientele, and for the next seventy-five years, he painted what people considered "good likenesses."[1]

From 1828 on, he crisscrossed central and western Massachusetts painting portraits. In 1831 he married Phebe Gilmur of Ware, Massachusetts, and completed more than twenty

Fig. 1 Erastus Salisbury Field (1805–1900). *Man with a Tune Book: Possibly Mr. Cook,* c. 1838. Oil on canvas; 89.1 x 73.8 cm (35⅟₁₆ x 29⅟₁₆ in.). National Gallery of Art, Washington, D.C., gift of Edgar William and Bernice Chrysler Garbisch, 1978.80.6.

portraits the following year in the Connecticut River Valley and the area around Hartford. The need to support a growing family required Field, like other itinerant portrait painters, to finish portraits in a day or single sitting. His increasing skill and rapid working style ensured his family's prosperity during the 1830s, when this portrait was painted.

Field's best portraits date from the period 1836–40, when he returned to Leverett. They are characterized by looser brushwork, good draftsmanship, and great attention to pattern, detail, and the decorative qualities of jewelry, lace, and props. This portrait is typical of Field's best work: the jewelry is carefully rendered, the sitter's collar and cap are painted in black and white to show pierced lace, and bows of pale pink accentuate her cheeks, lips, and nose. The figure fills the whole canvas, yet the artist emulated the grand tradition of portraiture by including a classical column at left, a carefully defined sweeping curtain, and a landscape behind the sitter. Nonetheless, she remains stiff, with awkward arms and squared-off fingers. Her face is not idealized, however; it is natural and well modeled.

The woman in this portrait is thought to be Louisa Gallond Cook of Petersham, Massachusetts, who married Nathaniel Cook in 1834. His portrait, *Man with a Tune Book*, is in the collection of the National Gallery of Art, Washington, D.C. (fig. 1). These companion portraits share the same poses, props, and backgrounds and also have the same measurements. The mother of two very young children, Mrs. Cook, who here looks old and wan before her time, died the year her portrait was painted, at age twenty-two.[2] The inclusion of a book in the portrait shows that she was cultured and literate. The National Gallery's portrait shows the sitter holding a tune book, identified by its oblong format.[3] Perhaps Mr. Cook had a musical affiliation or talent. Objects related to music often appear in Field's portraits, however, and may actually reflect the interests of the artist rather than the sitters.

Field's output of portraits waned after 1850. His wife died in 1859, and he spent the Civil War years in Michigan with his daughter, later returning to Sunderland, Massachusetts. The invention of photography made itinerant portrait painting less lucrative, and he began making large history paintings of biblical subjects and imaginary landscapes in the last decades of the nineteenth century.

1. Mary Black, "Erastus Salisbury Field, 1805–1900," in *American Folk Painters of Three Centuries*, ed. Jean Lipman and Tom Armstrong (Hudson Hills Press/Simon and Schuster, 1980), p. 74.

2. The identification of the sitters as the Cooks was made by Mary Black and published in *Erastus Salisbury Field, 1805–1900*, exh. cat. (Museum of Fine Arts, 1984), p. 106.

3. Deborah Chotner, *American Naive Paintings* (National Gallery of Art/Cambridge University Press, 1992), p. 128.

29

Doorframe, 1840/60
White pine; 306.1 x 240.4 cm
(120½ x 94⅝ in.)

Roger and J. Peter McCormick
endowments, 2008.554

Referencing Greek Revival ele-
ments, this imaginatively carved
doorframe suggests the whimsy and
unrestrained designs found in some
mid-nineteenth-century American
architecture. A classical vocabulary is
expressed through the carved shields,
abstracted lyres, anthemia, acorns,
and oak leaves on the doorframe's
pilasters, capitals, and lintel, but
it has been playfully reinterpreted
with the addition of stars and
exaggerated scrollwork.

The origin of this idiosyncratic
example of vernacular architecture is
unknown, but the white pine implies a
New England derivation. Oral history
suggests that the frame, found in the
Boston area, once graced a building
associated with Harriet B. Pierce, the
sister of President Franklin Pierce
and daughter of Governor Benjamin

Pierce of New Hampshire.[1] The Pierce homestead in Hillsborough, New Hampshire, featured gardens surrounding the house. Although there is no factual basis for this claim, local lore suggests that a latticed summerhouse—with this doorframe potentially gracing its facade—was part of the estate.[2]

Hattie B. Pierce was certainly connected with this doorframe sometime in the mid- to late nineteenth century, as she had a letterpress plate made of the doorway that she used to print greeting cards (fig. 1).[3] Although the letterpress plate suggests that this was

a doorway to a home, it is drastically different than most other doorframes in the United States from this period. The door, with its inset arched panels, along with a three-step staircase, suggests that the doorframe was part of an entry porch. Carved sometime after the Federal era but before the rise of fret-sawn Victorian confections, the doorframe exudes the spirit of American carpenters, who used sawn ornamentation as architectural adornment. And while tastemaker A. J. Downing recommended the "drapery of climbing plants" to adorn his country cottages, the print suggests the use of decorative potted plants.[4] "Amusing" doorways like the Art Institute's certainly did exist, but this folk expression defies the preferred styles of the nineteenth-century arbiters of good taste.[5] One notable exception (fig. 2) to more conservative examples is a decorative porchlike entry of a house in Baldwinsville, Ohio, which, like the Art Institute's doorframe, illustrates a strain of whimsy present in some vernacular architecture.

Beyond the president's sister, there were hundreds of women living in the nineteenth century with the name Hattie B. Pierce, making identification

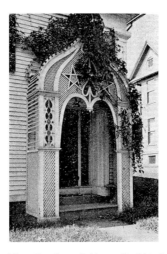

Fig. 2 *Doorframe.* Baldwinsville, Ohio. From Elbridge Kingsley and Frederick Knab, *Picturesque Worcester*, vol. 2 (W. F. Adams Co., 1895), p. 50.

of the owner of this doorframe difficult. Moreover, the maker of the doorframe also remains unknown. One architectural historian noted the similarities between the pilaster capitals of the doorframe and the trompe-l'oeil murals in the First Universalist Church, Provincetown, Massachusetts, created by German (or Swiss) immigrant Carl Wendte around 1845.[6] Perhaps the carving of the doorframe is so dissimilar to other American examples because, like the

Provincetown murals, it was the work of a craftsman who had recently immigrated to the United States.

1. Photographs reveal that the doorframe is not from the Pierce homestead in New Hampshire, however. Additionally, President Franklin's sister lived a short life (she died in 1837), and her name changed when she married Hugh Jameson on June 25, 1822. Frederic Beech Pierce, *Pierce Genealogy, Being the Record of the Posterity of Thomas Pierce, an Early Inhabitant of Charlestown* (Press of Chas. Hamilton, 1882), p. 100.

2. The claim that a latticed summerhouse adjoined the Pierce homestead is unsubstantiated. James L. Garvin, state architectural historian, New Hampshire Division of Historical Resources, e-mail message to the author, June 13, 2011. Files of the Department of American Art, Art Institute of Chicago.

3. The letterpress plate (2008.556) entered the Art Institute's collection with the doorframe.

4. "The Fireside: Dwellings and Their Ornaments," *Country Gentleman* (Mar. 17, 1853), p. 168.

5. For whimsical Greek Revival varieties, see Howard Major, *The Domestic Architecture of the Early American Republic: The Greek Revival* (J. B. Lippincott Co., 1926), pp. 68–69.

6. This was suggested by Robert O. Jones, senior architectural historian of the Rhode Island Historical Preservation and Heritage Commission.

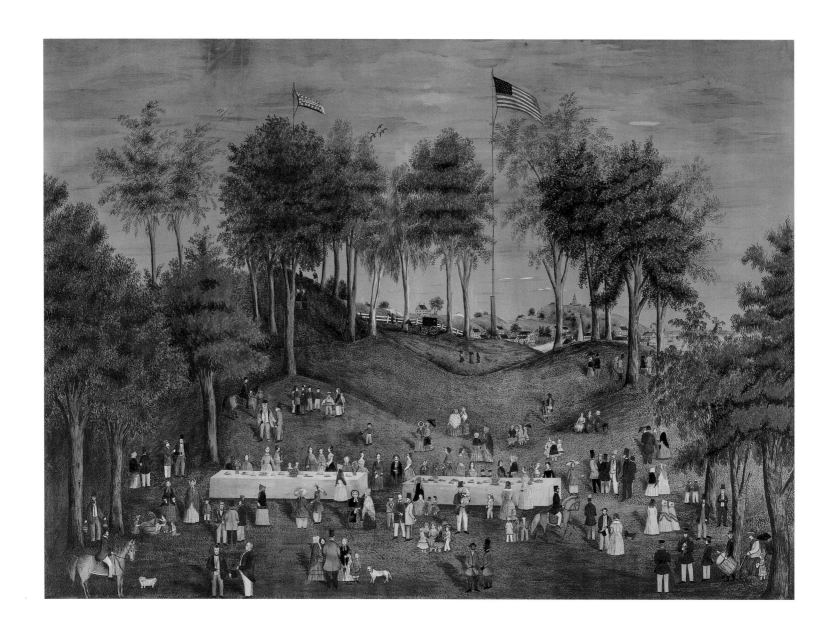

30

Susan Torrey Merritt (1826–1879)
***Antislavery Picnic at Weymouth
Landing, Massachusetts***, c. 1853
Transparent and opaque watercolor
with pen and black ink, graphite, black
crayon, and yellow metallic paint,
selectively heightened with gum
arabic, and cut-and-pasted collage
elements in like media on tan wove
paper; 66 x 91.4 cm (26 x 36 in.)

Gift of Elizabeth R. Vaughan, 1950.1846

Little is known about Susan Merritt,
and this is her only identified surviv-
ing work of art. Born in Weymouth,
Massachusetts, in 1826, she came
from a blacksmithing family that was
also musical: Susan's brother Amos
Jr. was a noted musician who played
bugle and other brass instruments in
the South Weymouth Band, and the
Merritts owned a pianoforte. Susan
seems to have been the only artist
in the family. She may have received
drawing instruction in school, as after
1848 the regulations for Weymouth's
public schools dictated that draw-
ing and penmanship be taught. Well

known as a local artist, after 1867 she
entered her art into competitions held
at the Weymouth Agricultural and
Industrial Society Fairs and regularly
won prizes, although none of these
pictures has survived.[1]

As much a mystery as the artist herself
is this superb watercolor drawing.
Evidence suggests that it is a com-
memorative picture of an important
event. Several scholars have put forth
theories about both its subject and its
date. The presence of the American
flag and the summer season suggest
a Fourth of July picnic. One observer
noted, however, that the flag is a
"Liberty" flag, associated with a politi-
cal party formed during the 1840s to
fight against the continuation and
expansion of slavery.[2] Consequently,
this picnic may actually be a political
event.[3] The presence of black figures
supports this idea, for whites and
blacks did not generally meet socially
in mid-nineteenth-century America
except at public events such as fairs
or rallies. The political nature of the
event is underscored by some of the
costumes featured in the picture. Two
women standing in front of the table
to the left, their backs to the viewer,
wear "Turkish trousers" beneath

shortened dresses. These outfits were
worn by many types of reformers:
women's-rights activists, Seventh-
Day Adventists, hydropathists (or
water-cure doctors), health reform-
ers, members of the national Dress
Reform Association, some Mormons,
and female members of utopian com-
munities. Turkish pants were pleated,
blousy, gathered at the ankle, and worn
under a pleated skirt. They were dif-
ferent, exotic, and offered freedom of
movement. The costume became a fad
during the early 1850s, but by the end
of the decade, it was out of fashion.

Merritt's political views on slavery and
women's rights are unknown, but the
climate in Boston and its environs in
the early 1850s was sympathetic to
both causes, and the artist was clearly
present at the event she illustrated
in what is today Weston Park. Her
biographer pointed out, however, that
the Merritt family had another event
to celebrate at the time she made
this picture—the marriage of her
sister Lucinda on July 4, 1853. Could
this painting have been a wedding
or anniversary gift? Are we perhaps
looking at members of the Merritt
family gathered at a picnic? Is Susan's
brother shown with his band members

at the lower right? The bugler in the
scene stands in the same pose and
uniform as Amos Merritt Jr. does in a
photograph of the Weymouth Band
taken in 1848.[4] Amos, a band member
until 1852, died in 1853. We will never
understand all the layers of mean-
ing celebrated and displayed in this
beautifully painted scene.

Over the years, writers have com-
mented that the figures in this painting
are printed cutouts glued to the surface
of the picture. Laboratory examina-
tion has shown this to be erroneous,
however. The presence of pencil and
gouache under the figures indicates
that they are not printed but painted.

1. Patrick J. Leonard, *Miss Susan Torrey Merritt
of South Weymouth, Massachusetts: An Artist
Rediscovered* (President Press, 1976), pp. 13–18.

2. Deborah Van Boekhoven, Department of
History, Ohio Wesleyan University, to the
Department of Prints and Drawings, Art
Institute of Chicago, Dec. 29, 1994. Files of
the Department of Prints and Drawings, Art
Institute of Chicago.

3. One of Weymouth's famous daughters,
Maria Weston Chapman, was an antislavery
crusader who helped William Lloyd Garrison
edit *The Liberator*.

4. The photograph of the Weymouth Band is in
the collection of the Tufts Library, Weymouth.

31

Face Jug, c. 1860
Edgefield District, South Carolina
Alkaline-glazed stoneware with kaolin;
h. 13.3 cm (5 ¼ in.)

Juli and David Grainger Fund, 2006.84

Although the origins, cultural significance, and function of early face jugs are uncertain, an African American slave in the Edgefield area of South Carolina likely made this vessel.[1] This diminutive jug was thrown by a skilled craftsman, and its sculptural, exaggerated facial features—including a wide mouth, flaring nostrils, and a single eyebrow that extends above both eyes—were applied with slip. Stoneware potters in the South developed the distinctive alkaline glaze used on this pot—a combination of wood ash or lime, clay, and sand or crushed glass.[2] Another characteristic of this face vessel—the contrasting light-colored insets (likely kaolin) used for the bulging eyes and teeth—demonstrates the skill of the potter, who had to consider the different shrinkage rates of the stoneware body and porcelain additions when fired.

Scholars have debated the origins of face jugs because a tradition of stylized face vessels exists in African, American, and European cultures, pointing to a complex web of varied cultural influences on Edgefield face jugs. For example, some scholars have suggested that English Toby jugs motivated the creation of face jugs because they were imported to the United States and Africa. John Michael Vlach wrote about the connection between face jugs and the *nkisi* figures of central and western Kongo, particularly the formal similarities

of bright white eyes and wide, open mouths.[3] Vlach built on Robert Farris Thompson's suggestion that many Edgefield slaves came from the Kongo region of central Africa, where there was a significant tradition of figural jug making.[4] *Nkisi* figures functioned as containers for sacred spirits, and given the proscription against the performance of African rituals by slaves, face jugs could have been used for religious practices.[5] Although the inclusion of kaolin eyes and mouths on a stoneware body suggests an artistic link between American-made face jugs and an African source, it is difficult to stake a definitive claim about the origin of this vessel because there were other African communities (particularly West African societies that participated in the Atlantic slave trade) that made anthropomorphic representations in clay. While we do not know whether these important vessels were used for utilitarian or symbolic purposes, they have been found along the Underground Railroad, suggesting that they were valuable enough to be carried by their owners as they escaped to freedom.[6]

An example of an Edgefield face jug—formerly in the collection of Elie Nadelman and his Museum of Folk and Peasant Arts and later acquired by the New York Historical Society—was illustrated in the *Index of American Design*, demonstrating its place in the early canon of American folk art.[7]

1. John Michael Vlach, "International Encounters at the Crossroads of Clay: European, Asian and African Influences on Edgefield Pottery," in *Crossroads of Clay: The Southern Alkaline-Glazed Stoneware Tradition*, ed. Catherine Wilson Horne (McKissick Museum/University of South Carolina, 1990), p. 29.

2. For more information on the glaze, see Cinda K. Baldwin, "The Scene at the Crossroads: The Alkaline-Glazed Stoneware Tradition of South Carolina," in *Crossroads of Clay: The Southern Alkaline-Glazed Stoneware Tradition*, ed. Catherine Wilson Horne (McKissick Museum/University of South Carolina, 1990), pp. 41–87.

3. John Michael Vlach, *The Afro-American Tradition in Decorative Arts* (Cleveland Museum of Art, 1977).

4. Robert Farris Thompson, "African Influence on the Art of the United States," in *Afro-American Folk Art and Crafts*, ed. William Ferris (University Press of Mississippi, 1983), pp. 27–63.

5. See Mark M. Newell with Peter Lenzo, "Making Faces: Archaeological Evidence of African-American Face Jug Production," *Ceramics in America* (2006), pp. 122–38.

6. Regenia A. Perry, *Selections of Nineteenth-Century Afro-American Art* (Metropolitan Museum of Art, 1976), p. 11.

7. See Virginia Tuttle Clayton, *Drawing on America's Past: Folk Art, Modernism, and the Index of American Design* (National Gallery of Art/University of North Carolina Press, 2002), pp. 118–19.

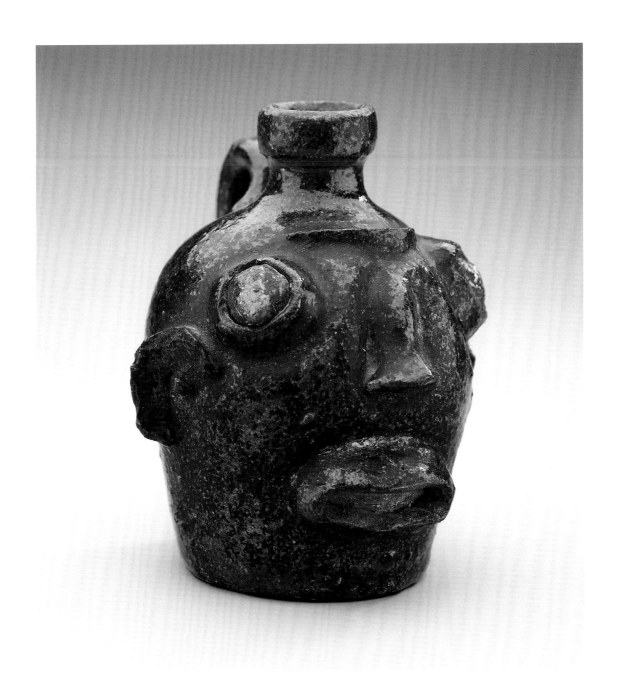

32

Side Chair, 1825/75
Zoar, Ohio
Chestnut and oak; 97.8 x 45.8 x 35.5 cm
(38½ x 18 x 14 in.)

Restricted gift of Jamee J. and
Marshall Field; Charles F. Montgomery
through exchange; Charlotte Olson,
Mr. and Mrs. John Trumbull, and
Elizabeth R. Vaughan funds, 1982.204.1

With beliefs that diverged from those
of the Lutheran Church, the sepa-
ratists of Zoar had strong political,
moral, and spiritual convictions that
led them to escape persecution in
Germany by immigrating to the United
States. Joseph Bimeler and his three
hundred followers from Würtemburg
established a religious, communal
society in Zoar, Ohio, in 1817. They
founded the village adjacent to the
Tuscarawas River, which provided
them with a mode of transportation
and the power to operate factories,
thus aiding in the creation of a wealthy
and self-sustaining community. Zoar
underwent a crisis in leadership
when Bimeler passed away in 1852,
but it persevered until the end of the
nineteenth century.[1]

Beyond other utilitarian goods,
the cabinet shop in Zoar produced
furniture for the community using
available wood, including elm, oak,
beech, chestnut, walnut, and maple;
later, furniture was available for sale
to outsiders.[2] This chair features four

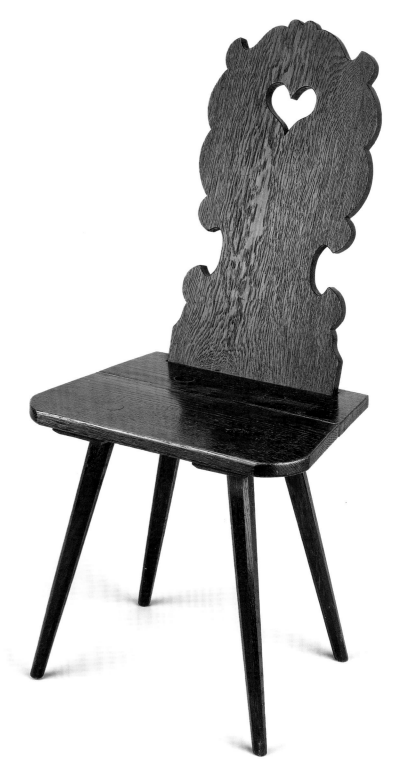

splayed and chamfered legs tennoned and wedged through a chestnut batten to the plank seat. The decorative oak back splat is morticed (and secured with wooden pins) through the round-cornered seat, which gradually widens toward the front of the chair. The fancifully shaped back splat references Germanic vernacular chairs; in fact, chairs of this variety have also been found in Pennsylvania German areas from the mid-eighteenth century, suggesting a similar European source.[3] The pierced heart design found on many Zoar objects contributes a whimsical and folksy touch.

Included in the Art Institute's collection is a paper pattern for the chair back (fig. 1). This design is inscribed in pencil, "Josehp [sic] Bunehuter [or Bauhater]," perhaps suggesting the maker or user of the chair.[4] The use of chair patterns ensured uniformity in design and scale in order to produce a dependable, identical product for the Zoar community.

Fig. 1 *Back Pattern for Side Chair*, 1825/75. Zoar, Ohio. Ink on paper; 64.8 x 30.2 cm (25½ x 11⅞ in.). The Art Institute of Chicago, restricted gift of Jamee J. and Marshall Field; Charles F. Montgomery through exchange; Charlotte Olson, Mr. and Mrs. John Trumbull, and Elizabeth R. Vaughan funds, 1982.204.2.

1. For a history of the Zoar community, see "The Society of Separatists of Zoar" in Catherine Rokicky, *Creating a Perfect World: Religious and Secular Utopias in Nineteenth-Century Ohio* (Ohio University Press, 2002), pp. 53–85.

2. Wildred Freed McArtor, "Arts and Industries of the Zoarites, 1817–1898" (MA thesis, Ohio State University, 1939), pp. 100–01.

3. The Philadelphia Museum of Art has a number of these Pennsylvania German chairs with plank construction and a decorative heart-shaped back splat (28-10-65, 28-10-66, and 30-44-2), as does the Winterthur Museum (63.827).

4. The names Bunehuter and Bauhater are not located in Zoar records in the Archives Library of the Ohio History Society (Matthew Benz, curator, Ohio Historical Society, e-mail correspondence with the author, Apr. 23, 2010). There are many possible reasons for this: the name could have been inscribed during a later period, leading to a misspelling; Germanic names have been transcribed variously throughout the nineteenth and twentieth centuries in the United States, causing difficulties in spelling; and the pencil inscription, which has faded over the years, is difficult for a contemporary viewer to read.

33

Esther Allen Howland (1828–1904)
"First" American Valentine, c. 1849
Quincy, Massachusetts
Cut-and-pasted paper with gouache
on die-cut and embossed ivory wove
paper lace border heightened with
silver ink, tipped on pale-purple wove
paper; 251 x 200 mm (9⅞ x 7⅞ in.)

Gift of Emma B. Hodge, 1919.524

Although she did not create the first American valentine, Esther Howland was an important early figure in the American valentine trade.[1] After graduating in 1847 from Mount Holyoke, she either saw or received an English valentine, which sparked her interest in design.[2] Before the mid-nineteenth century, valentines were largely imported from England unless they were handmade. Howland helped establish Worcester, Massachusetts, as a center of valentine production in the United States when she began advertising her services through her father's stationery store in the February 5, 1850, edition of the *Daily Spy*: "Valentines. Persons wishing to select from the best assortment in the City are invited to call on S. A. Howland, 143 Main Street."[3] Her initial foray into business was successful, and soon she employed enough women to create an assembly line, in which each worker handled a specific task in order to keep up with orders.

Called the "first fancy valentine made in the United States," this was one of two initial samples created by Howland.[4] Her early valentines used imported paper lace and floral and figural trimmings. This example features a border of machine-made paper lace meant to evoke handmade lace, and a basket of flowers that, in addition to its traditional symbolic value, serves an artistic purpose by providing depth to the composition. One of the design innovations that Howland pioneered was the use of colored paper, which was both economically prudent and aesthetically appealing. Participating in the folk tradition of love poetry and the reinvigoration of Valentine's Day in the United States, Howland's beautifully crafted valentines combined women's interests in fashion, sentimentality, and consumption.[5]

Emma B. Hodge lent (and later donated) her collection of early American and English valentines, including this example, to the Art Institute. They formed the basis of the museum's first valentine exhibition, held in February 1915.[6]

1. Howland referred to this valentine as the progenitor of American valentines in her Feb. 14, 1901, letter to Mr. A. W. Brayley of Boston, Massachusetts. She wrote, "Please accept the first valentine made in the United States, with the compliments of the maker." The envelope in which the letter is currently held reads, "Presentation of the first fancy made valentine in America signed by Miss Howland." The letter and envelope are in Esther Howland's workbox, which is in the collection of the Department of Prints and Drawings of the Art Institute of Chicago.

2. This tale has been frequently retold. Either Howland received an English valentine from a gentleman, or her father, as a stationer, imported some for sale.

3. S. A. (Southworth A.) Howland was Esther Howland's father, and his firm was named S. A. Howland and Sons. The advertisement copy was reprinted in Ruth Webb Lee, *A History of Valentines* (Studio Publications, 1952), p. 54.

4. Arthur W. Brayley, "The Girl Who Invented the First American Valentine," *Ladies' Home Journal* (Feb. 1903), p. 41.

5. See Leigh Eric Schmidt, "The Fashioning of a Modern Holiday: St. Valentine's Day, 1840–1870," *Winterthur Portfolio* (Winter 1993), pp. 209–45.

6. This popular exhibition would be reprised at the Art Institute in 1917 and 1926 and at the Children's Museum in 1927, 1929, and 1933.

34

Jesse Hart (1814–1894)
Coverlet, 1851
Wilmington, Ohio
Cotton and wool, plain weave double
cloth; woven on loom with Jacquard
attachment; both selvages present;
229.9 x 198.3 cm (90½ x 78¼ in.)

Gift of Dr. Frank W. Gunsaulus,
1915.519

Inscribed: *If good we plant not, vice
will fill the place; And rankest weeds
the richest soils deface; wove by J Hart
Wilmington Clinton County Ohio 1851*

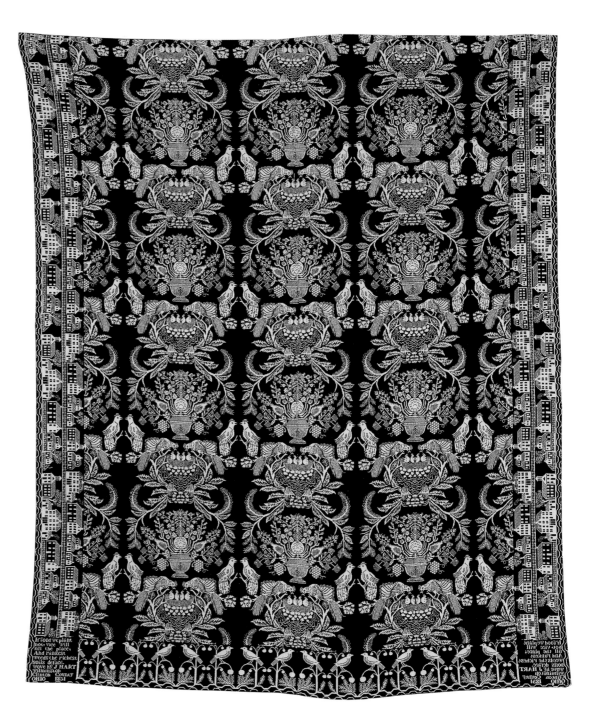

Middle-class Americans procured brightly figured coverlets as fashionable home furnishings beginning in the second quarter of the nineteenth century. Hand weavers, including Jesse Hart, used technologies such as a handloom with Jacquard attachment to create coverlets for consumers, who delighted in their ability to produce colorful patterned coverlets. Born in Beaver County, Pennsylvania, in 1814, Hart grew up on a farm and learned several trades, including weaving, at an early age. Although he wove for eighteen years, he also worked as a carpenter and a wagon maker, thus serving as an example of a nonprofessional weaver.[1]

There are many different types of coverlets, which can be organized by technical construction into basic groups: overshot, summer and winter, and multiple shaft (categories of handloom construction); and double cloth (tied or plain) and *beiderwand* (woven on handlooms, handlooms with Jacquard attachments, or power looms). The location of production further distinguishes types of coverlets.[2] Like many Ohio coverlets, Hart's example is of a double-cloth type. It was made with indigo, which was readily obtained and produced a reliable color that easily coordinated with other colors. Patterns were shared by weavers, which explains the similar designs found on many coverlets. Hart's coverlet includes a pattern that has been called "Birds of Paradise," "Penelope's Flower Pot," or "Birds Feeding Their Young" in the central panel, and a border composed of the "Boston Town" pattern and "Birds and Cherry Trees." "Birds of Paradise," illustrating exotic birds feeding their young in a nest, was one of the most popular patterns during the 1840s.[3] It was also fashionable to include inspiring moral verses on coverlets. In the corner of this coverlet, Hart incorporated the verse "If good we plant not, Vice will fill the place; And rankest weeds the richest soils deface," a phrase with widespread appeal. It likely originated in English evangelical literature, and by the 1840s, it surfaced in American farming journals.[4]

Beyond their bold color and graphic content, coverlets functioned as material evidence of the transition between earlier skilled handloom production and the increasing importance of automatic factory looms in the New England textile trade. They were attractive to collectors of folk art on aesthetic and technical grounds. This coverlet is one of sixty donated by Frank W. Gunsaulus—an important minister, president of the Armour Institute, and Art Institute trustee—to the museum.

1. Pliny A. Durant, *The History of Clinton County, Ohio* (1882; repr., Heritage Books, 2002), p. 866.

2. Mildred Davison and Christa C. Mayer-Thurman, *Coverlets: A Handbook on the Collection of Woven Coverlets in the Art Institute of Chicago* (Art Institute of Chicago, 1973), p. 18.

3. Mildred Davison, "Hand-Woven Coverlets in the Art Institute of Chicago," in *The Art of the Weaver*, ed. Anita Schorsch (1925; repr., Universe Books, 1978), p. 240. See also Clarita Anderson, *Weaving a Legacy: The Don and Jean Stuck Coverlet Collection* (Columbus Museum of Art/H. N. Abrams, 1995), pl. 50, for a similar example.

4. This phrase was penned by Hannah More, a playwright-turned-moral-author, in 1818 and used as a "poet's sentiment" in the Church of England's magazine in 1826. Although More did not originate the phrase, she and others aided in its popularization. Its moral implications were not lost on the writers of the *The Farmers' Cabinet* when they used it to discuss the virtues of good planting. See Hannah More, *The Works of Hannah More*, vol. 1 (T. Cadell and W. Davies, 1818); *The Christian Guardian, and Church of England Magazine* (L. B. Seeley and Son, 1826); and *The Farmers' Cabinet and American Herd-Book* (Josiah Tatum, 1843).

35

Eva Barbara Kügler (active 1853)
Memorial of Thanks, 1853
Possibly Michigan
Gouache, watercolor, pen and brown
and black ink, and pinpricked designs
on cream wove paper; 300 x 372 mm
(11 1/16 x 14 5/8 in.)

Gift of Robert Allerton, 1927.627

An ornamental letter to the artist's
godparents, *Memorial of Thanks* was
signed by Eva Barbara Kügler on
May 5, 1853. The message begins:
"Memorial of Thanks. God's rich
blessings are a part of your way of life
and the good you have done for me,
written to God blessings in 1853."[1]
The letter is stylistically similar to a
confirmation certificate (*patenspruch*)
made by Johann George Nuechterlein
in Frankenmuth, Michigan, on April
9, 1876 (fig. 1). The two documents
share a similar border surrounding a
central heart flanked by stylized water-
color tulips alongside pinpricking that
creates another layer of decoration.
In order to achieve exact symmetry,
Kügler folded her certificate in half
before pricking the document. The
women in the lower corners, each

holding a flag and riding a large lamb
composed of pinpricks, are a curious
element of the design; it is unclear
whether this imagery was meant to be
humorous or religious. Interestingly,
Raitersaich, the ancestral home of
Kügler, is a part of Rosstal, Germany,
from where the Neuchterlein family
emigrated. Additionally, the List family,
who also hailed from Rosstal, had one
member who made pinprick lambs
on a certificate, suggesting that this
imagery is part of a shared decorative
vocabulary from that part of Bavaria.[2]

This letter of thanks is stylistically
different than the more commonly
known Pennsylvania German frakturs.
The Art Institute's *Baptismal Certificate*
(fig. 2) was made in Bethel, Lebanon
County, Pennsylvania, on the occasion
of a baptism on April 24, 1816. In this
hand-drawn example, which utilizes
a common color scheme, the artist
attempted a symmetrical composition
of tulips, pomegranates, urns of flowers,
and birds. The fraktur and Kügler's
Memorial of Thanks demonstrate the
range of illustrated manuscripts cre-
ated by Americans of German descent
during the nineteenth century in
Pennsylvania and Michigan.

1. The original German reads, "Denkmal des
Dankes / Gottes reiche wonne Segen / Sei Ihr
Theil auf Ihren Wegen / Und was Sie mir Guts /
gethan Schreibe / Gott zum Segen / au / 1853."

2. Mary Nuechterlein, e-mail correspondence
with the author, Apr. 12, 2011. Files of the
Department of American Art, Art Institute
of Chicago. The German immigration of 1845
brought many Franconians and Bavarians to
Michigan; they settled in St. Clair, Macomb,
and Saginaw counties, where towns like
Frankenmuth were founded.

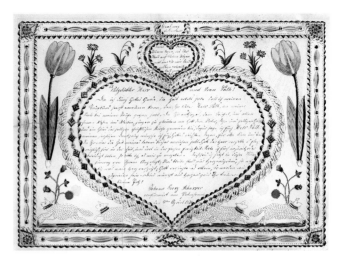

Fig. 1 Johann George Nuechterlein. *Confirmation Certificate (Patenspruch)*, April 9, 1876.
Frankenmuth, Michigan. Watercolor and pinprick on paper; 405 x 510 mm (16 3/8 x 20 1/16 in.).
Frankenmuth Historical Museum.

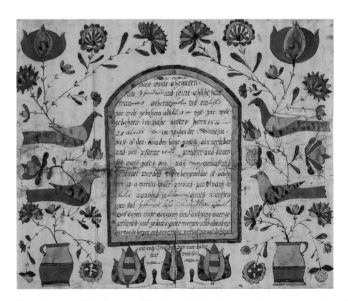

Fig. 2 *Baptismal Certificate*, 1816. Brush and yellow, brown, and green watercolor, with pen
and black ink, and pen and brush and opaque red ink, on cream laid paper; 333 x 409 mm
(13 1/8 x 16 1/16 in.). The Art Institute of Chicago, Samuel P. Avery Endowment, 1922.97.

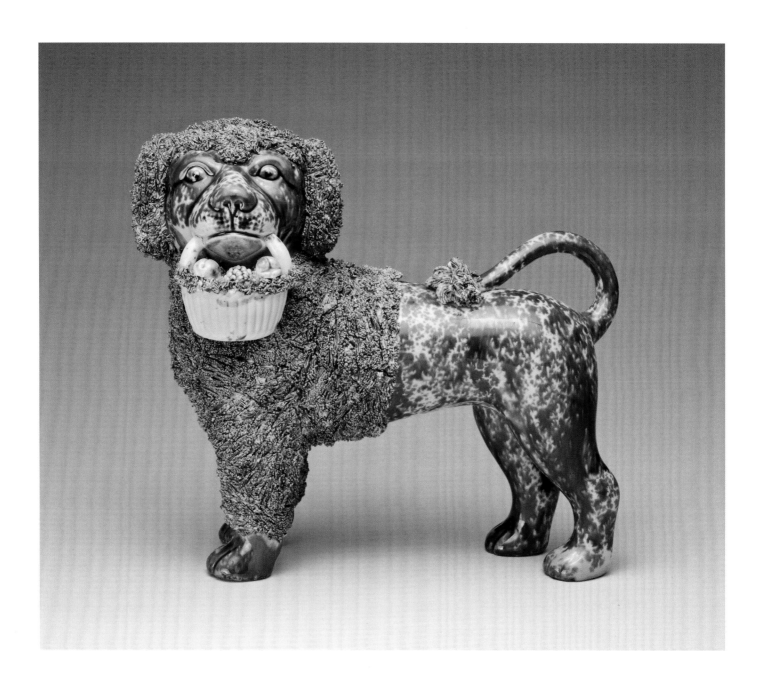

36

Attributed to Lyman, Fenton and Company (1849–52) or United States Pottery Company (1852–58)
Standing Poodle, 1849/58
Bennington, Vermont
Earthenware; 21.6 x 23.2 x 11.4 cm
(8 ½ x 9 ⅛ x 4 ½ in.)

Amelia Blanxius Collection, gift of Mrs. Emma B. Hodge and Mrs. Jene E. Bell, 1912.933

Fashionable from the mid-nineteenth through the early twentieth century, American Rockingham ware derives its name from an 1807 invoice for teapots from a pottery on the English estate of the Marquis of Rockingham.[1] This English "tortoiseshell ware," so named for its distinctive mottled-brown glaze in the Rococo taste, enjoyed a resurgence in popularity in the United States during the mid-nineteenth century. Many potteries in New England and Ohio produced American Rockingham wares, based on the original English examples, with a variety of mottled effects (mainly in brown, but sometimes in colors ranging from yellow to blue and olive), which were

inexpensive and ubiquitous in the American domestic landscape.

The potteries of Bennington, Vermont, were strongly influenced by their famous predecessors in Staffordshire, England (fig. 1), both in the type of wares they produced and in the spirit of the artistic community. Many Staffordshire potters immigrated to the United States, where they worked in established potteries (some even founded their own firms). Benefiting from experienced English designers and modelers, one such pottery was Lyman, Fenton and Company, which pioneered (and patented) a flint enamel glaze that produced brilliant shades of red, orange, yellow, green, blue, olive, and brown.[2] The firm changed its name a few years later, in 1852, to United States Pottery Company, and it is likely that *Standing Poodle* was made at one of these two related firms.[3]

The poodle was a very popular subject in the Victorian era, and animals—including lions, cows, deer, and dogs—frequently appeared in American ceramics of the period. Made in pairs, figurines such as this poodle would have been used as mantel decorations. This one, missing its mate, was covered in a light Rockingham glaze, with flint enamel glazed fruit in a white basket. The applied mane—known as "coleslaw" decoration by generations of Staffordshire potters—was made of shredded clay formed by pushing moist clay through a screen. Called the "Bennington poodle," this sculpture was illustrated in the *Index of American Design* as a folk art object.

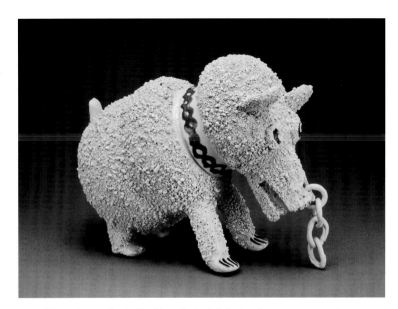

Fig. 1 *Tobacco Jar*, 1750/85. Staffordshire, England. Salt-glazed stoneware; 23.5 x 18.4 cm (9 ¼ x 7 ¼ in.). The Art Institute of Chicago, gift of Mr. and Mrs. William DeBracy Wilson, 1948.553.

Standing Poodle was collected by Emma B. Hodge for the Amelia Blanxius Collection. Hodge wrote proficiently about many aspects of pottery, including Bennington wares, which she admired for their "variegated glazes of great depth and richness of coloring."[4] Influential curator and ceramics author Edwin Atlee Barber characterized her collection as a representative example that "has been gathered together with rare judgment and discrimination."[5]

1. Jane Perkins Claney, *Rockingham Ware in American Culture, 1830–1930: Reading Historical Artifacts* (University Press of New England, 2004), p. 32.

2. Arthur F. Goldberg, "Highlights in the Development of the Rockingham and Yellow Ware Industry in the United States—A Brief Review with Representative Examples," *Ceramics in America* (2003), pp. 26–46.

3. Some scholars have asserted that the poodle was designed by John Harrison. See John Spargo, *The Potters and Potteries of Bennington* (1926; repr., Dover Publications, 1972), p. 229; and Diana Stradling, *"Fancy Rockingham" Pottery: The Modeller and Ceramics in Nineteenth-Century America* (University of Richmond Museums, 2005).

4. Emma B. Hodge, "History of English Pottery and Porcelain: The Amelia Blanxius Collection at the Art Institute of Chicago Illinois," n.d., p. 65. Files of the Department of European Decorative Arts, The Art Institute of Chicago.

5. Edwin Atlee Barber, "Blanxius Collection of Porcelain," Apr. 1912. Art Institute of Chicago Archives.

37

S. Bell and Sons (1882–1908)
Mug, 1882/92
Strasburg, Virginia
Redware; h. 18 cm (7½ in.)

Bequest of Elizabeth R. Vaughan,
1950.1683

Marked: *S. Bell & Son, Strasburg*

Fig. 1 John Bell (1800–80). *Jug,* 1850/80. Waynesboro, Pennsylvania. Stoneware; 31.1 x 15.6 cm (12¼ x 6⅛ in.). The Art Institute of Chicago, bequest of Elizabeth R. Vaughan, 1950.1677.

Extending from Pennsylvania to Virginia, the Shenandoah Valley was a prime area for ceramic production due to its abundance of red clays. Made in Strasburg, Virginia, this mug is part of a rich history of pottery in the region.[1] The Bell family of potters originated with Peter Bell Jr. (1774–1847), who worked in Hagerstown, Maryland, and Winchester, Virginia. His sons— including John (1800–1880), who potted in Waynesboro, Pennsylvania (see fig. 1), and Samuel (1811–1891) and Solomon (1817–1882), who ran a firm in Strasburg, Virginia—continued the family tradition. When Solomon passed away in 1882, the firm became S. Bell and Sons with the addition

of Samuel's sons Richard Franklin (1845–1908), Turner Ashby (1866–1931), and Charles Forrest (1868–1933). S. Bell and Sons was a maker of both stoneware and earthenware.

This red earthenware mug is marked near the rim with the inscription "S. Bell & Son, Strasburg," which corresponds to the first years of the firm's production (before it declined). The large mug's rim is incised with four lines to form a triple band, and the body includes one incised band. Over cream slip, brightly colored glazes provide a polychromatic surface. Manganese and copper glazes produced green and brown mottled

shades, which gave Shenandoah Valley pottery its distinctive aesthetic. This utilitarian object was rendered functional with a coat of clear lead glaze.

1. See H. E. Comstock, *The Pottery of the Shenandoah Valley Region* (Museum of Early Southern Decorative Arts/University of North Carolina Press, 1994).

38

Oval Box, c. 1850
Canterbury, New Hampshire
Pine, maple, and copper;
7.9 x 21.3 x 14 cm (3⅛ x 8⅜ x 5½ in.)

Delphine G. Schoen Trust, John W.
Pluth, and Stanley and Polly Stone
endowments; Woman's Board
American Art and Mrs. Richard
Bennett funds, 2008.492

Made in the mid-nineteenth century by the Shaker community of Canterbury, New Hampshire, this oval box exemplifies the simple, unadorned aesthetic of Shaker design.[1] Oval boxes used for storage were produced in large quantities from the 1790s through the 1940s by Shakers for their own use and for sale through outlets, including Shaker wagons, village stores, and summer hotels. Reflecting their religious beliefs, Shakers crafted furnishings that bespoke principles of honesty, order, utility, and cleanliness. This oval box would have been part of a series of standard graduated boxes intended for the storage of dry goods. While the top and base are made of pine, the body was constructed of malleable maple, cut on one end into fingers or laps (also called "swallowtails" by the Shakers), and then steamed and wrapped around an oval mold. The fingers keep the joint from buckling by providing room for the wood to expand and contract over time. Gracefully affixing the fingers to the box were copper tacks, which prevented rusting or rotting. This tidy, handsomely constructed box retains its original orange paint, which is rare, as many twentieth-century owners stripped stained surfaces to expose the wood beneath. Shaker objects began to be collected as fashionable goods in the 1930s.

The inclusion of a Shaker oval box in the *Index of American Design* aided in the identification of Shaker material as distinctly American—both within the narrative of design history and as folk art.[2]

1. For more information on the Shakers, see Jean M. Burks, *Shaker Design: Out of This World* (Yale University Press, 2008); and John T. Kirk, *The Shaker World: Art, Life, Belief* (Henry N. Abrams, 1997).

2. For more on the origins and impact of the *Index of American Design,* see Virginia Tuttle Clayton, Elizabeth Stillinger, and Erika Lee Doss, *Drawing on America's Past: Folk Art, Modernism, and the Index of American Design,* exh. cat. (National Gallery of Art, 2002).

39

Sewing Desk, 1860/70
Canterbury or Enfield, New
Hampshire
Cherry, birch, ash, and maple with
ceramic drawer pulls; 106.7 x 80 x
68.9 cm (42 x 31½ x 27⅛ in.)

Gift of Mrs. James M. McMullan and
Mrs. James D. Vail III through the
Antiquarian Society, 2003.8

The austere simplicity and delicate refinement of Shaker design is expressed in this sewing desk made in either Canterbury or Enfield, New Hampshire. The Shakers—a Protestant sect who lived in celibate, agriculturally oriented, communal cooperatives in New York, New England, and the Midwest—are well known for their simple yet elegant furniture. By the mid-nineteenth century, Shakers gained a notable reputation for excellent craftsmanship, which enabled them to turn their cottage furniture industry into a major enterprise (see cat. 38). Simplicity and restraint characterize Shaker furniture, along with the use of rectilinear lines, a lack of ornamentation, and an emphasis on function. This desk, with its original ceramic drawer pulls, stored sewing implements and provided a work surface for hemming or fancy work. The replacement of the rear panel (in pine) indicates that the desk may have been attached to the wall or placed back-to-back with an identical desk, a hypothesis consistent with the concept of communal living and working central to the Shaker belief system.

The Shaker population declined in the twentieth century. The Enfield Shaker community closed in 1923, and the remaining members moved to Canterbury (which remained active until 1992). This desk could have been moved as villages closed and Shaker objects were sold in the mid-twentieth century.[1] In a photograph published in the March 16, 1957, issue of the *Berkshire Eagle* newspaper (Pittsfield, Massachusetts), Eldress Emma B. King stands in front of the desk (fig. 1). This photograph was taken in the trustees' office in Hancock Shaker Village in Pittsfield, Massachusetts. King traveled to Pittsfield because Frances Hall, the last trustee at Hancock, passed away in March 1957; King was compelled to make recommendations for the Shaker community. Although the eldress was a member of the East Canterbury, New Hampshire, community, she was instrumental in shaping the future of the Shakers as a member of the central ministry. In the fall of 1956, she wrote *A Shaker's Viewpoint,* in which she outlined the early hopes and desires of the faithful before the decline of Shaker society, which had been caused by competition, the attractiveness of the modern world, and celibacy.[2] King implacably repeated that the faith would persevere, declaring that "Shakerism is no failure."

Fig. 1 William Tague. Photograph of Emma B. King in front of the Art Institute's sewing desk, 1957. Shaker Museum and Library, Old Chatham, New York.

1. With their financial assets in disarray, Shakers were often forced to sell their furnishings. Emma King wrote, "The old-time relics are dear to us and only the immediate need of money would induce us to part with them." Stephen J. Stein, *The Shaker Experience in America: A History of the United Society of Believers* (Yale University Press, 1992), p. 395.

2. Emma B. King, *A Shaker's Viewpoint* (Shaker Museum Foundation, 1957), n.pag.

40

Ship Figurehead: Native American Bust, c. 1860
New York, New York
White pine and paint; h. 74.9 cm
(29½ in.)

George F. Harding Collection,
1982.1199

Female Bust, 1800/30
Northeastern United States
White pine and paint;
h. 36.8 cm (14½ in.)

George F. Harding
Collection, 1982.1175

Chicago politician and real-estate magnate George F. Harding Jr.'s collection included arms and armor, paintings, sculpture, musical instruments, and maritime objects. The "ship room" and second-floor balcony of Harding's "castle," the turreted addition to his Hyde Park home, housed his collection of marine paintings, ship models, naval memorabilia, weaponry, ship figureheads, and carvings.[1] Much of Harding's collection eventually came to the Art Institute after his home ceased to function as a museum.

Attached to the prow of a vessel, a ship figurehead was intended to appeal to a wide public audience. New York City, a center of wood carving (see cat. 48), was also a hub for ship-building from 1820 on. Likely carved there, this Native American bust with a flattened, plumed headdress is set on a scrolled bow piece.[2] In excellent condition, it has large drift-pin holes in the chest that likely indicate its point of attachment to a ship. Its carving utilizes the visual language of the Noble Savage, a popular depiction of Native Americans in the nineteenth century that romanticized the "vanishing race." Although the figure's

identity remains unknown, the carving may portray Native American leader Tecumseh or Osceola.[3] According to the Harding Museum inventory, this figurehead was displayed in Harding's front entrance hall, perhaps indicating its prominence in his collection.

There was a wide range of carving in Harding's collection, including female subjects that adorned ships beginning in the late eighteenth century (see fig. 1). Although it was part of the Harding Museum, there is no material evidence that *Female Bust* was created as a ship's figurehead. This dynamic carving retains an old, possibly original surface. The exaggerated locks of hair, widely spaced facial features, and elegantly delineated chest required excellent carving skills, making this a superb and exuberant example of folk sculpture.

1. Harding Museum Records, Harding Collection, Ryerson and Burnham Archives, Art Institute of Chicago.

2. This figurehead has long been confused with a signed figurehead bearing the inscription "J Bowers 1861." The signed figurehead, currently in a private collection, was likely the one sold at Anderson Galleries, New York, Nov. 12–13, 1925, no. 72, from the William Bell Chambers Collection.

3. This was suggested by Daniel Finamore, Russell W. Knight Curator of Maritime Art and History, Peabody Essex Museum. Files of the Department of American Art, Art Institute of Chicago.

Fig. 1 *Ship Figurehead: Female Bust*, 1800/15. White pine and paint; 55.3 x 35.6 cm (21¾ x 14 in.). The Art Institute of Chicago, George F. Harding Collection, 1982.1178.

41

Rug, 1850/1900
Jute, plain weave with cotton and wool yarns; felted, knitted, and woven strips forming "hooked" pile; edged with cotton and wool, oblique interlacing; 181.8 x 190.6 cm (71 5/8 x 75 in.)

Gift of Emily Crane Chadbourne, 1952.179

After a commercial pattern designed by Ebenezer Ross (active c. 1890–1900)

Rug Entitled "Lion with Palms,"
1890/1900
Jute, plain weave with wool and cotton yarns, knitted and woven strips forming "hooked" pile; edged with cotton, twill weave; 152.8 x 77.3 cm (60 1/8 x 30 3/8 in.)

Bequest of Elizabeth R. Vaughan, 1950.1136

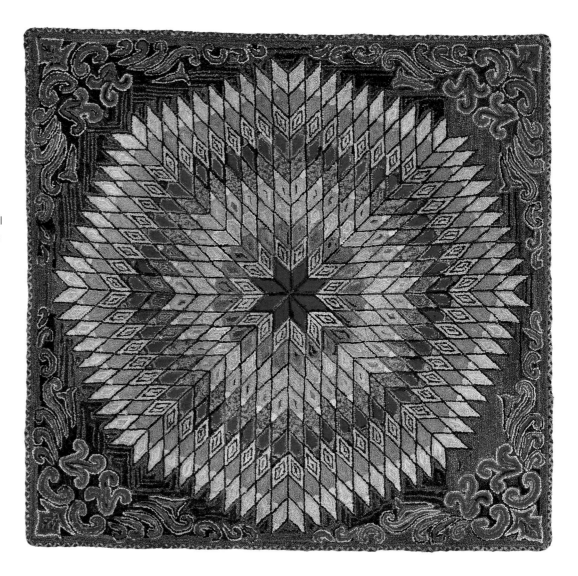

Although historians debate the origin of the hooked rug, Americans defined this field of folk art during the nineteenth century. Hooked rugs chronicle the artistic pursuits of resourceful women in the United States. Textiles were a precious and labor-intensive commodity in the colonial era, and hooked rugs allowed women to create objects of "fancy" work out of otherwise unusable materials.

Early rugs employed yarn and old garments that were cut into strips of the same size and dyed uniform colors. On a background of homespun linen, and later factory-made cotton or burlap (jute), cloth strips made out

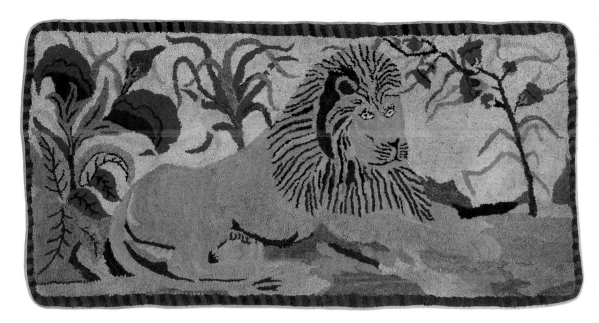

production later in the nineteenth century to make hooking easier. Based on a commercial pattern by Ebenezer Ross, the "Lion with Palms" rug became a popular, oft-reproduced design. Although the general layout of the design was similar to those of other rugs, the maker could improvise certain areas, such as the background; in this example, instead of rendering palms, the rug hooker crafted a background of flowering bushes and wispy trees.[5] Both earlier, freely designed hooked rugs and their late-nineteenth-century industrially enhanced counterparts were collected beginning in the late nineteenth century as genuine examples of American folk art.

of wool spun into yarn or hand-woven materials were looped through the ground. Choosing from a wide range of decorative treatments, the maker of this rug hooked strips in a design combining a geometric pattern and floral scrollwork onto a jute ground, which had become the customary backing material for such rugs by the late 1850s.[1] The pattern on this rug can be compared to ones found on quilts, particularly the "Star of Bethlehem" design (fig. 1). The language of repeating diamond-shaped pieces concentrically arranged around a central star is commonly found in both hooked rugs and quilts of the nineteenth century. This interest in repetitive, expanding stars has been linked to the invention of the kaleidoscope.[2]

The shape of this square rug varies from more standard rectangular or half-circle formats; based on its large size, it could have functioned as a bed rug. Hooked rugs returned to fashion in the early twentieth century as a part of contemporary interior decoration, with some writers identifying folk art as a source of modern design.[3]

As more textiles became available to Americans in the early nineteenth century, the popularity of hooked rugs surged.[4] The entrepreneurial New England tin peddler Edward S. Frost identified an opportunity to make stencils to replicate hooked-rug designs, creating standardized patterns. Similarly, in lieu of hand-manipulated cloth, industrially made woolen strips became available through machine

Fig. 1 *Quilt* (detail), c. 1850. Cotton, plain weaves; some printed; pieced; edged with cotton, plain weave; printed; backed with cotton, plain weave; quilted; 218.4 x 220.3 cm (86 x 86¾ in.). The Art Institute of Chicago, gift of Elizabeth Hyde Holden, 1950.1526.

1. The category of "floral geometrical" hooked rugs was designated by an early authority, William Winthrop Kent, in *Rare Hooked Rugs, and Others, Both Antique and Modern, from Cooperative Sources* (Pond-Ekberg Company, 1941).

2. See the "The Kaleidoscope," in Sumpter T. Priddy, *American Fancy: Exuberance in the Arts, 1790–1840* (Chipstone Foundation/D.A.P., 2004), pp. 81–97.

3. For examples of contemporary articles, see Walter Rendell Storey, "Old Arts Are Revived for Decoration," *New York Times*, May 2, 1926, p. SM14; Walter Rendell Storey, "Home Decoration: Folk Art a Source of Modern Design," *New York Times*, Feb. 11, 1940, p. 57.

4. Interestingly, Emily Crane Chadbourne, who donated this rug to the Art Institute, had another similarly rare hooked rug in her collection that she gave to the museum (1952.177); for a comparable hooked rug, see Kent (note 1), p. 90.

5. Other examples may be seen in Joel and Kate Kopp, *American Hooked and Sewn Rugs: Folk Art Underfoot* (Dutton, 1975), p. 81.

42

John Haley Bellamy
(1836–1914)
Eagle, c. 1890
Kittery Point, Maine
Pine, paint, and gold leaf;
43.2 x 74.3 cm (17 x 29¼ in.)

Bequest of Elizabeth R. Vaughan,
1950.1981

American carvers have always been keen observers of animals, putting them on weather vanes, ships, and business signs. The eagle, adopted by the Continental Congress of the United States in 1782, became the most popular emblem of the new republic and a favorite American motif that denoted patriotism.[1] John Bellamy is best known for his carved eagles. The son of a man involved in the boat-building trade, he knew the commercial and navy boatyards of New England. Bellamy, a resident of Kittery and Portsmouth, apprenticed in Charlestown in 1857 and quickly became known for his bold, brightly colored eagles. He established his own shop with employees who carved and assembled eagles by the hundreds,

many for ships commissioned by the federal government; these were installed in the Portsmouth, Charlestown, and Boston navy yards.

Bellamy's eagles have spread wings draped in the American flag and hold a shield; they were usually made of dried, aged white-pine boards that were painted and gilded. Starting with a thick piece of seasoned pine an inch

and a half in depth, he used a template to trace lines onto the wood and then sawed out the form. He employed a hatchet or knife to gouge out the design and feather the wings. For larger and more three-dimensional pieces, he sometimes laminated

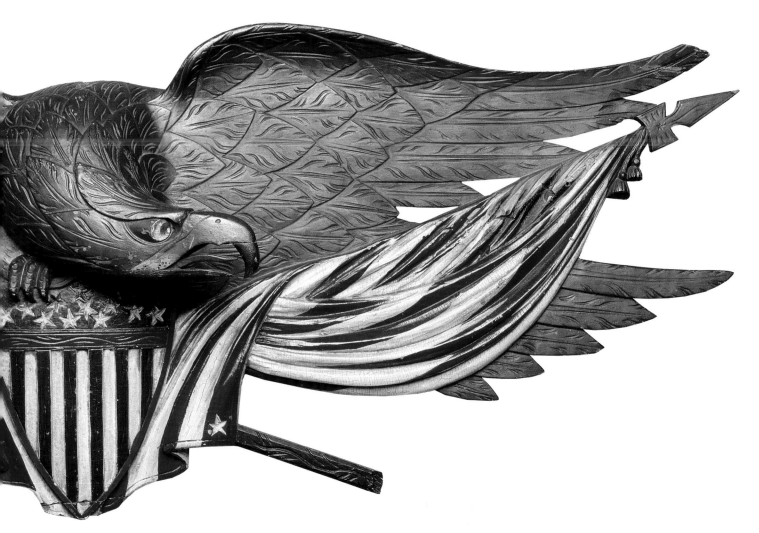

boards together. The eagle's head was then whittled from a separate block and joined to the wings with hot animal-hide glue.[2] Typical of Bellamy's work is the "shelving" of the wings in this example: he introduced a hollow beneath the upper line of the wing to achieve an overhang and suggest greater definition. Like the best folk artists, he captured the three-dimensional realism of the bird with an economy of stroke; a fluid, calligraphic grace; and bold color.

1. Benjamin Franklin preferred the turkey, and John James Audubon argued for the kingfisher as the emblem of the United States.

2. Yvonne Brault Smith, *John Haley Bellamy: Carver of Eagles* (Portsmouth Marine Society/ P. E. Randall, 1982), p. 38.

43

Charles Spencer Humphreys
(1818–1880)
*George Franklin Archer and the Archer
Residence*, 1871
Oil on canvas; 62.2 x 76.5 cm
(24½ x 30⅛ in.)

Through prior acquisition of the
George F. Harding Collection, 1987.43

Signed lower right: *Chas. S. Humphreys.
1871*

Born in Moorestown, New Jersey, the
painter Charles Spencer Humphreys
was the son of Joshua Humphreys, a
storekeeper. By the age of nineteen,
he had moved to Camden, where he
shared business premises with his
brother, Richard.[1] There he met and
married the daughter of a prominent,
wealthy Camden real-estate devel-
oper, Caroline Fetters. He remained in
Camden for most of his career, painting
or lettering signs for local merchants
and attorneys; painting wagons,
harnesses, breast straps, and even
"tomb boards"; and decorating church
interiors. But it was his portraits of
horses, which seem to have been his
favorite type of painting, that were
most sought after. Of the approxi-
mately twenty extant easel paintings
by Humphreys, most are portraits of
trotting or harness-racing horses.[2]

*George Franklin Archer and the Archer
Residence*, painted in 1871, appears
to have been commissioned by the
horse's owner to commemorate
the horse, his son, and his property.
The painting is signed and dated
by Humphreys, but it also exhibits
all the hallmarks of his style. Horse
and rider are displayed in profile in
front of a landscape, the horse's legs
carefully placed in a trotting pose.
The landscape differs from some of
Humphrey's other subjects in that it is
a residence rather than a racecourse.
Especially intricate are the artist's
depictions of the brick buildings and
the detail and foreshortening of the
fence. Humphreys no doubt used
photographs to guide him, as an

albumen silver print of the Archer
residence (c. 1860s) was acquired with
the painting (fig. 1). The photograph
captures the Italianate Revival house
from almost the same view as the
painting, and the fence is identical to
that in the photograph. The detailed
rendering of Archer's (1853–1914) face
suggests that his portrait was also
taken from a photograph.

The number of outbuildings in the
painting and what appears to be a
corral or track behind the subject
points to the Archers' standing in the
community and the world of horses.
Humphreys was a well-known painter
during his lifetime in both Camden
and Philadelphia, an important
national center of horse racing that
provided him with great opportunities.

1. Archibald McElroy, *McElroy's Philadelphia
Directory for 1843*, 6th ed. (Edward C. Biddle,
1843), p. 315, lists the brothers as "painters" at 5
Lanning's Row.

2. David C. Munn, "Charles S. Humphreys
Revisited," *Bulletin of the Camden County
Historical Society* (1986/87), pp. 6–7;
Biographical Review Publishing Company,
*Biographical Review: Containing Life Sketches
of Leading Citizens of Burlington and Camden
Counties, New Jersey* (Biographical Review Pub.
Co., 1897), pp. 299–300; and Deborah Chotner,
American Naive Paintings (National Gallery
of Art/Cambridge University Press, 1992),
pp. 213–14.

Fig. 1 Photograph of the Archer family in front of their residence, c. 1860s. The Art Institute
of Chicago, through prior acquisition of the George F. Harding Collection, 1987.43.

44

Artist unknown
Rysdyk's Hambletonian, after 1876
Oil on canvas; 63.5 x 76.2 cm
(25 x 30 in.)

Gift of Mrs. Rudyard Boulton,
1950.1358

Hambletonian (1846–1876) was one of the most famous trotters in American racing history. His fame endures today, as he is the progenitor of many current harness-racing horses. Here the horse is posed with his owner, William M. Rysdyk (1809–1870), in his stable in Chester, Orange County, New York. Rysdyk was a hard-working farmhand who saved enough money to buy a mare and colt from his employer in 1849. The bay colt proved to be very fast, and soon demand grew for Hambletonian's stud services. Rysdyk became wealthy, building a mansion between 1860 and 1865 in Chester. By that time, Hambletonian's progeny were also sought-after trotters with brilliant careers, and the Hambletonian boom had begun. By the horse's death in 1876, he had sired over 1,300 foals. Forty of those set trotting records.[1] Today Hambletonian's name lives on in the Hambletonian Stakes, one of the most prestigious harness-racing events in the United States.

Hambletonian's fame led to a series of portraits of him with his owner. Supposedly, crowds traveled hundreds of miles for a glimpse of the horse through a narrow, grated window in his stall, which was fiercely guarded by Rysdyk. Eccentric and suspicious, he carefully scrutinized all visitors before allowing certain ones to look at the famous horse. An artist named James Henry Wright convinced Rysdyk to allow him to paint a portrait of horse and owner together. Rysdyk was so delighted with the picture that he bought it. Subsequently, it was reproduced by several companies as a lithograph and became well known in taverns, farms, auction houses, and public places throughout the Northeast in the last quarter of the nineteenth century.[2]

Several lithographs after Wright's painting exist. The first, signed "J. H. Wright, 1865," was lithographed by Henry C. Eno and printed by John J. Olone, New York, in 1866 (fig. 1). Currier and Ives also produced a version of the painting in an 1876 lithograph for its *Famous Horses* series, designed by Louis Maurer. Eno published another version of the painting around 1876 (the year of Hambletonian's death). In some posthumous Hambletonian lithographs, the horse stands alone, with Rysdyk expunged from the plate.

Unsigned, and less complicated than any of these prints, this picture was probably painted from the engraving published in the *Massachusetts' Ploughman and New England Journal of Agriculture* on April 15, 1876, just days after Hambletonian's death. The painting is even more spare than the engraving: the dado is replaced by a plain wall, and the horse blanket is more simply folded. The untrained artist melded beautiful, warm, earthy ochers in a modern-looking composition.

1. M. Horace Hayes, *Points of the Horse: A Treatise on the Conformation, Movements, Breeds and Evolution of the Horse*, 3rd ed. (Hurst and Blackett, Ltd./C. Scribner's Sons, 1904), pp. 569–71.

2. "Sudden Fad for a Horses' [*sic*] Portrait," *New York Times*, Dec. 22, 1901.

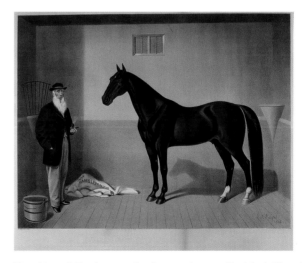

Fig. 1 Henry C. Eno (active mid-19th century), printed by John J. Olone. *Rysdyk's Hambletonian*, 1866. Lithograph; 483 x 638 mm (19 x 25⅛ in.). Smithsonian National Museum of American History, Peters Collection.

45

Painted by Uriah Dyer (1849–1927)
Works by Silas Hoadley (1786–1870)
Tall-Case Clock, 1820/84
Plymouth, Connecticut; and North
Appleton, Maine
Painted pine and gilded copper-alloy
iron; h. 195.6 cm (77 in.)

Bessie Bennett, Laura T. Magnuson,
and Wendell Fentress Ott
endowments, 1996.438

Signed on face: *S. HOADLEY,
PLYMOUTH*; on case: *U. N. Dyer,
House & Sign Painter. No. Appleton*

Objects, like people, have lives and experience change. This clock case, created in Connecticut around 1820 by an unknown cabinetmaker, contains works made by Silas Hoadley, a Plymouth, Connecticut, clockmaker active between 1790 and 1840. Decades passed before the clock arrived in the shop of Uriah Dyer of North Appleton, Maine, who advertised himself as a house and sign painter. In 1884 he decorated the clock for Dr. Phineas A. Crooker of Warren, Maine.[1]

Dyer treated the surface of the clock as a blank canvas, leaving no space uncovered. His decoration blends history and contemporary fashion. He painted vignettes of the history of Warren and depicted events from 1645 and 1750—a log cabin and fight between white settlers and Native Americans, and settlers struggling against bears, respectively. At the base of the clock (fig. 1), a scene entitled "Lovewell's Fight" (1725) illustrates another conflict between settlers and the native population, in which several

hundred Native Americans burned a sloop, sawmill, houses, and block-houses before finally being contained by the local garrison. Captain John Lovewell of Dunstable petitioned the General Court of Massachusetts (Maine was part of Massachusetts at that date) for the right to raise scouting parties and make retaliatory raids against the Native Americans, who were considered dangerous pests. The court agreed and offered a bounty of one hundred pounds for every scalp the settlers brought back. Lovewell, who died during the resulting fight, was considered a patriot and hero. Henry Wadsworth Longfellow even wrote a poem about the event.[2] Dyer concluded his decoration with a vignette of the Revolutionary War battle of Lexington.

Dyer, obviously familiar with the fashion for Japanism, painted the plain areas of the clock black to suggest ebony and created gold-painted surfaces and cartouches framing the scenes. Japanese-inspired, flattened

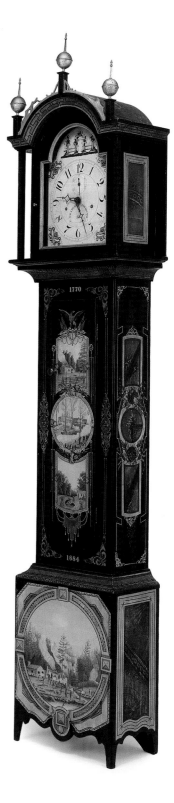

designs that suggest patterned screens were painted on each side of the clock. The self-taught artist probably turned to contemporary pattern books, bookbinding, printed textiles, or painted ceramics for inspiration. A lifelong resident of Appleton, Dyer was an artistic jack-of-all-trades who included sign painting, landscape painting, cabinetmaking, portraiture, and photography among his many skills.[3]

1. Dyer signed and dated the clock; Crooker's initials are painted on the inside of the waist door, above Dyer's trompe l'oeil trade card.

2. Longfellow's poem is entitled "Ode Written for the Commemoration at Fryeburg, Maine, of Lovewell's Fight." The story is recounted in Cyrus Eaton, *Annals of the Town of Warren, in Knox County, Maine*, 2nd ed. (Hallowell, Masters and Livermore, 1877), p. 38. For a thorough analysis of the importance of Lovewell's mission see Gail H. Bickford, "Lovewell's Fight, 1725–1958," *American Quarterly* 10, 3 (Autumn 1958), pp. 358–66.

3. Mark Sisco, "Appleton, Maine, Folk Artist Uriah Dyer," *Maine Antique Digest* 20, 1 (Jan. 1992), pp. 2E–3E.

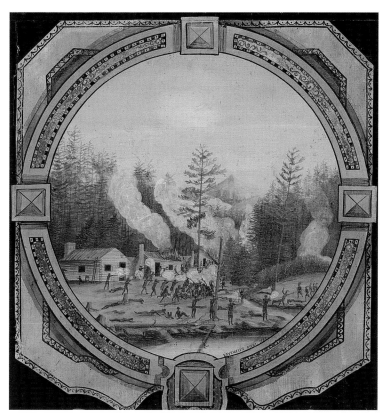

Fig. 1 Detail of *Tall-Case Clock* (cat. 45), 1820/84.

46

Country Preacher, 1860/90
White pine and paint; 73.7 x 26.7 x
31.8 cm (29 x 10½ x 12½ in.)

Elizabeth R. Vaughan Fund, 1956.1199

Folk sculpture presented an alternative
to the academic tradition prevalent
in nineteenth-century America. Folk
carvers crafted cigar-store figures, ship
figureheads, whirligigs, and objects
such as *Country Preacher*. Unlike the
Art Institute's face jug (cat. 31), which
depicts a grotesque evocation of an
African American, this black preacher
is portrayed in a solemn, dignified
manner, leading some scholars to rea-
son that he was carved by an African
American.[1] Preachers were authority
figures in African American com-
munities, and after the Civil War, their
presence served to unify freed but
poor black communities. This sculp-
ture references such preachers, who
used religion to influence and organize
their communities.

Made of white pine, *Country Preacher*
is covered in gold paint (with traces

of brown, black, red, and white). The
figure, carved in the round, wears a
frock coat that loosely falls to the
ground over the wooden crate on
which he is seated. His face was ren-
dered with portraitlike realism, and his
scruffy beard, curly hair, penetrating
gaze, down-turned mouth, and deeply
wrinkled brow suggest an actual
person's features. Very long fingernails
grasp the pages of a book, perhaps the
Bible. Interestingly, the sculptor varied
the scale of anatomical parts—abnor-
mally long fingers are contrasted with
inconceivably tiny feet.

This sculpture is one of a larger group
of seated African American preacher
figures that have appeared in southern
Ohio and Kentucky, perhaps the
area of origin of the Art Institute's
Country Preacher.[2]

1. Regenia Perry, *What It Is: Black American Folk
Art from the Collection of Regenia Perry*, exh. cat.
(Anderson Gallery, Virginia Commonwealth
University, 1982), n.pag.

2. Files of the Department of American Art,
Art Institute of Chicago.

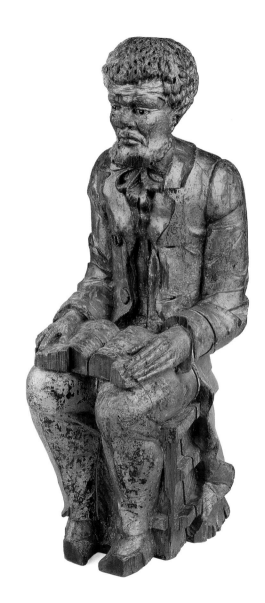

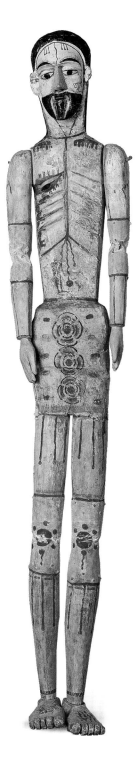

47

José Benito Ortega (1858–1941)
Cristo, 1880/1907
Wood, fabric, and paint; 143.2 x 27.3 cm
(56 ⅜ x 10 ¾ in.)

Simeon B. Williams Fund, 1983.528

Because of its relative isolation under Spanish and Mexican rule until 1846, New Mexico developed a distinctive Hispanic culture that was different than that of other American regions. Representative of the religious folk art of the Southwest, *santos* (or holy images) were crafted in two forms— *retablos* (painted wood panels) and *bultos* (wooden sculptures), which were generally fashioned by nonprofessional artists. The standing figure of Christ was one type of *bulto* made for devotional purposes.

Earlier generations of *santeros* (artisans who made *santos*) created *bultos* for newly built churches, but by the late nineteenth century, when *santero* José Benito Ortega was active, most of his figures were made for private homes, *moradas* (meeting houses), and some village churches.[1] Not much is known about Ortega, who was born in La Cueva, Mora County, New Mexico, on March 20, 1858. He made *santos* for almost thirty years, until his wife died in 1907, and perhaps had family assistance in the trade (suggested by his prolific output).[2] Ortega likely made this figure, as its form and style are closely related to other *bultos* by him.[3] Perhaps missing a crown of thorns, Christ was carved out of a soft wood

(likely cottonwood), with gesso and red, green, and yellow paint applied for decorative effect. This work bears many characteristics of Ortega's other sculptures of Christ, including black-outlined eyes with lashes suggested by dots; a bold, straight nose; a black beard and goatee; a flat neck and chest; a chest bearing incised ribs, a painted navel, and an open wound; and a loincloth painted with round designs suggesting rosettes.[4] Perhaps meant to stand on a platform, the brightly colored figure was expressively painted in red to suggest blood and wounds. In combination with the red paint, the large size of the sculpture would have solemnly reminded pious observers of Christ's bodily struggle to save humanity.

1. Marie Romero Cash, *Santos: Enduring Images of Northern New Mexican Village Churches* (University Press of Colorado, 1999), p. 165.

2. Larry Frank, *A Land So Remote*, vol. 2 (Red Crane Books, 2001), p. 489.

3. Curator Jina Brenneman, Harwood Museum of Art, suggested an Ortega *santo* (1996.0012.0000) for comparison. See Jina Brenneman, e-mail correspondence with the author, Feb. 25, 2011. Files of the Department of American Art, Art Institute of Chicago.

4. Frank (note 2), pp. 492–93.

48

Samuel Anderson Robb (1851–1928)
Indian Chief, 1888/1903
White pine and paint; 201.9 x 57.8 x
62.6 cm (79½ x 22¾ x 24⅜ in.)

Sanford Fund, 1952.143

Incised on front of base: *Cigars. / G. B. Fairgrieve. / Tobacco.*; on lowest part of base: *Robb Manufr, 114 Centre St. N.Y.*; on right side of base: *Twitchell. Champlin & Co. / Portland. ME. / Sole Agents for / S. Ottenberg & Bros.*; on left side of base: *S. Ottenberg / & Bros. / Cigar Manufrs / N.Y.*

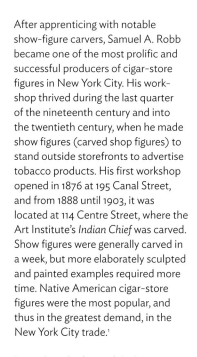

After apprenticing with notable show-figure carvers, Samuel A. Robb became one of the most prolific and successful producers of cigar-store figures in New York City. His workshop thrived during the last quarter of the nineteenth century and into the twentieth century, when he made show figures (carved shop figures) to stand outside storefronts to advertise tobacco products. His first workshop opened in 1876 at 195 Canal Street, and from 1888 until 1903, it was located at 114 Centre Street, where the Art Institute's *Indian Chief* was carved. Show figures were generally carved in a week, but more elaborately sculpted and painted examples required more time. Native American cigar-store figures were the most popular, and thus in the greatest demand, in the New York City trade.[1]

Incised on the front of the base is "G. B. Fairgrieve," which likely refers to George B. Fairgrieve of Somerset County, Maine. Little is known about Fairgrieve, who was the proprietor of a saloon and a cigar store at 10 Madison Street in Skowhegan, Maine.[2] It is highly probable that this figure

prominently advertised Fairgrieve's tobacco shop. Also noted on the base are Twitchell, Champlin and Company and S. Ottenberg and Brothers,[3] a New York City cigar manufacturer that sold exclusively to Twitchell, Champlin and Company, the Portland wholesale grocer and provision dealer that distributed merchandise to Maine retailers, including Fairgrieve.[4]

The Newark Museum displayed cigar-store figures of different varieties in the 1931 exhibition *American Folk Sculpture*, and they were also included in the *Index of American Design*, thus codifying this category of American folk art by the early 1930s.

1. "Carving Wooden Figures: How They Are Made and the Uses They Are Put To," *New York Times*, May 30, 1882, p. 2.

2. Edmund S. Hoyt, *Maine State Year-Book and Legislative Manual, for the Year 1885–86* (Hoyt, Fogg and Breed, 1886), p. 604.

3. For more information on S. Ottenberg and Brothers, see "Chapters in Cigar History VI. Isaac Ottenberg and Sons," *Tobacco Leaf* (Nov. 18, 1896), p. 5.

4. Edward H. Elwell, *The Successful Business Houses of Portland* (W. S. Jones, 1875), pp. 29–32.

49

Ladislaus Zdzieblowski (1857–1929)
Desk, 1893
Oak; 190.5 x 149.8 x 67.3 cm
(75 x 59 x 26½ in.)

Gift of the family of Irene M. Groenier
in her memory, 1989.439

Immigrating to Chicago in the
late nineteenth century, Ladislaus
Zdzieblowski became a naturalized
United States citizen on October
7, 1892.[1] He was employed by the
Pullman Palace Car Company of
Chicago as a designer of furniture
for private cars.[2] Before settling in
Chicago, according to family history,
he studied woodworking in Nancy,
France. Zdzieblowski was one of
many immigrants who went to Nancy
because it was a prosperous city and a
center for luxury glass and marquetry.

Zdzieblowski's substantial oak desk
is visually lightened with burled oak
panels and drawers. The Renaissance
Revival–inspired desk is architec-
tonic in appearance, with engaged
Ionic columns, galleries, and a

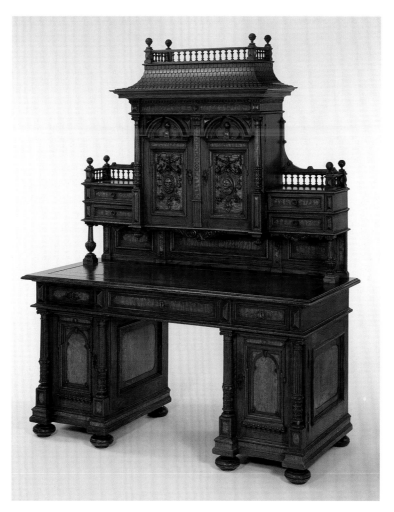

pediment that resembles a shingled
pitched roof. In a patriotic gesture,
on the central doors are two carved
medallions on strapwork cartouches
featuring George Washington and
Tadeusz Kościuszko, who fought in
the American Revolutionary War

as a Continental Army colonel of
engineers. Both men served fearlessly
to advance the cause of American
freedom during the Revolutionary
War. The Polish colonel was a fitting
choice to balance Washington as a
war hero.

Zdzieblowski exhibited this desk dur-
ing Chicago's 1893 World's Columbian
Exposition in the Manufactures and
Liberal Arts Building. Family history
notes that the desk was retrieved
before the building burned (in 1894),
thus saving it from destruction.[3]
Extremely proud of his accomplish-
ment, Zdzieblowski lived with the
desk in his home and passed it on to
subsequent generations as a family
heirloom, until it was donated to the
Art Institute.

1. Zdzieblowski's naturalization papers (from
the Superior Court of Cook County) reside in
the Files of the Department of American Art,
Art Institute of Chicago.

2. Jean Groenier Stiefel (granddaughter of
Zdzieblowski), oral history, recorded Aug. 28,
1989, Files of the Department of American
Art, Art Institute of Chicago. In trying to verify
the artist's employment with the Pullman
Company, the author consulted the Pullman
Archives at the Newberry Library but did not
find Zdzieblowski's name (as it is spelled on his
naturalization papers).

3. Ibid.

50

Wilhelm Schimmel (1817–1890)
Eagle, 1870/90
Cumberland County, Pennsylvania
Painted and carved tulipwood;
33.7 x 68 cm (13¼ x 26¾ in.)

Bequest of Elizabeth R. Vaughan,
1950.1984

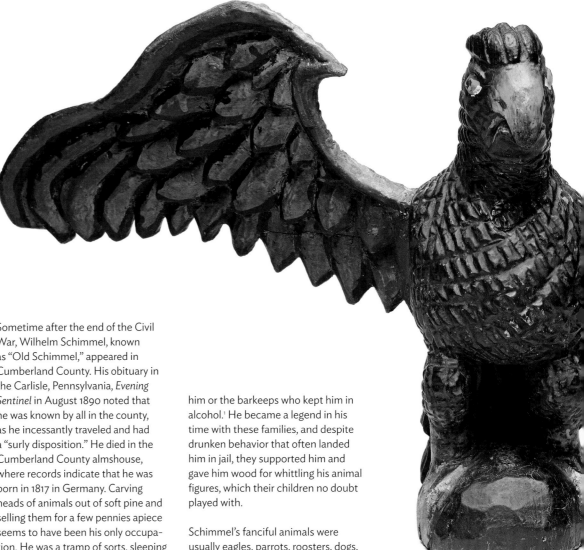

Sometime after the end of the Civil War, Wilhelm Schimmel, known as "Old Schimmel," appeared in Cumberland County. His obituary in the Carlisle, Pennsylvania, *Evening Sentinel* in August 1890 noted that he was known by all in the county, as he incessantly traveled and had a "surly disposition." He died in the Cumberland County almshouse, where records indicate that he was born in 1817 in Germany. Carving heads of animals out of soft pine and selling them for a few pennies apiece seems to have been his only occupation. He was a tramp of sorts, sleeping in barns and occasionally doing chores or watching the children of the German families who housed and fed him or the barkeeps who kept him in alcohol.[1] He became a legend in his time with these families, and despite drunken behavior that often landed him in jail, they supported him and gave him wood for whittling his animal figures, which their children no doubt played with.

Schimmel's fanciful animals were usually eagles, parrots, roosters, dogs, lions, and squirrels (see fig. 1). His carvings were sometimes covered in a gessolike ground and then brightly

painted. His eagles show more intricate, if irregular, carving patterns than some of his other animals. He first shaped the body of the bird, making a crosshatch pattern with a penknife, and then carved and articulated the wings. He pegged or doweled the wings to the body. Schimmel may also have polished his carvings with a piece of glass before applying gesso and finally paint. Since he did not sign his work, the animal figures are attributed to him based on technique and their often fierce, imposing postures.

Indeed, they are as cantankerous in appearance as Schimmel himself was reported to have been.

1. Milton E. Flower, *Three Cumberland County Wood Carvers: Schimmel, Mountz, Barrett* (Cumberland County Historical Society, 1986), pp. 6–9.

Fig. 1 Wilhelm Schimmel. From left to right: *Eaglet*, 1870/90. Carved and painted wood; 26.4 x 10.2 cm (10 ⅜ x 4 in.). The Art Institute of Chicago, Elizabeth R. Vaughan Fund, 1956.1131; *Rooster*, 1870/90. Carved and painted wood; 15.2 x 10.8 cm (6 x 4 ¼ in.). The Art Institute of Chicago, Bequest of Elizabeth R. Vaughan, 1950.1991.

51

Attributed to Jacob Brunkeg
Hanging Box with Lid, 1891
Probably Michigan
Wood; 33 x 47 x 53.3 cm
(13 x 18½ x 21 in.)

Gift of Harold Allen, 1997.557

Inscribed on reverse: *Jacob Brunkeg
15 Sep. 1891 / Denk An Mih*

Cathedral Clock Case, 1935
Probably Wisconsin
Wood; 55.9 x 47.6 x 20.3 cm
(22 x 18¾ x 8 in.)

Gift of Harold Allen, 1997.556

From the Civil War until the Great
Depression, artists creatively reused
discarded materials—thin pieces of
wood that were shaped, layered, glued,
and notch-carved—to fashion "tramp
art." In an early attempt to codify the
field of tramp art, Helaine Fendelman
established a set of characteristics
to distinguish the art form, which
includes chip-carving, layering pieces

of wood (via glue or nails), the use
of cigar-box wood, and, occasionally,
applied and inlaid decoration.[1]

The word *tramp* entered into popular
parlance in the United States during
the 1870s.[2] Itinerant edge-carvers
became associated with the term
because they appeared to live as
vagabonds, although the true identity
of most tramp artists is unknown.
While the mythology of the artist-
tramp or the itinerant hobo was
pervasive (see cat. 50), notch-carving
became a part of popular culture. This
pastime expanded in the late nine-
teenth century with the availability of
guidebooks, including *Fret-Sawing and
Wood-Carving for Amateurs* (1875) and
A Manual of Wood Carving (1891).[3] In
fact, the author of one of these books
suggested to his readers that "when
a cigar-box factory is not accessible,
one can buy, for a few cents, empty
boxes at the local cigar stores where
they are usually glad to get rid of
them."[4] The majority of tramp art was
composed of salvaged scrap materials,
including cedar cigar boxes, the wood
of which was soft and available. The
Art Institute's clock case, which was
found in Wisconsin, bears cigar-box
labels on its interior.[5] This whimsical

interpretation of a cathedral—in
which the clock face approximates a
rose window and the pointed notch-
carved members represent towers
or lancet windows—also includes a
shingled roof and varying shapes on
the facade of the clock. There is a
sophisticated sense of positive and
negative space, with areas built up
in high relief contrasting with others
created by carved gaps.

Between 1900 and 1925, when tramp
art reached its peak of popularity,
there was a fad for carving personal
and functional objects for the home,
which included the Art Institute's
clock case and hanging box. Perhaps
made in Michigan, the small hang-
ing box is signed on the reverse. On
a chip-carved heart is the inscrip-
tion "Jacob Brunkeg 15 Sep. 1891 /
Denk An Mih" ("Think of me"), with
two hands with outstretched fingers
pointing toward each other.[6] The
box is composed of several layers of
notch-carved receding rectangles on
the front and sides, with an anchor
covering the top.

Even during the years of tramp art's
decline, it remained a popular art form
in the Midwest. *The Art of Whittling*

was published in Peoria, Illinois, in
1930, and as part of a Works Progress
Administration project, the Chicago
Park District published a manual on
whittling in its *Modern Recreation*
series.[7] Tramp art became less
prevalent with the increase in the mass
production of goods, the decline of
cigar smoking (diminishing the avail-
ability of cigar boxes), and advances in
technology (reducing leisure pursuits
involving handcrafts).

1. Helaine W. Fendelman, *Tramp Art: An
Itinerant's Folk Art* (E. P. Dutton, 1975), pp. 11–13.

2. Todd McCallum, "The Tramp Is Back,"
Labour/Le Travail 56 (Fall 2005), pp. 237–50.

3. These two examples were among many carv-
ing manuals written during the late nineteenth
and early twentieth centuries. George A.
Sawyer, *Fret-Sawing and Wood-Carving
For Amateurs* (Lee and Shepard/Shepard
and Dillingham, 1875); and Charles Godfrey
Leland, *A Manual of Wood Carving*, rev. ed.
(C. Scribner's Sons, 1891).

4. Sawyer (note 3), p. 39.

5. Files of the Department of American Art, Art
Institute of Chicago.

6. Nothing is known of Jacob Brunkeg, the
presumed maker of this box, who wrote "think
of me" in German on it on Sept. 15, 1891.

7. Walter L. Faurot, *The Art of Whittling* (Manual
Arts Press, 1930); and *Whittling: A Distinctively
American Craft* (Chicago Park District, 1937).

52

Frank Memkus (1884–1965)
Whirligig, 1939/45
Painted wood and metal; 205.1 x 73.7 x 101.6 cm (80¾ x 29 x 40 in.)

Restricted gift of Marshall Field, Mr. and Mrs. Robert A. Kubiceck, James Raoul Simmons, Mrs. Esther Sparks, Mrs. Frank L. Sulzberger, and the Oak Park-River Forest Associates of the Woman's Board of The Art Institute of Chicago, 1980.166

Lithuanian immigrant Frank Memkus crafted this whimsical whirligig as an amusement during World War II, while he was living in Milwaukee, Wisconsin. Little is known about Memkus, except that he worked at a tannery in Tomahawk upon immigrating to Wisconsin. The Tomahawk Tannery was established in 1903, destroyed by fire in 1906, and rebuilt by 1908.[1] A second fire in 1927 devastated the tannery, and Memkus was likely compelled to move to Milwaukee when it closed.[2] He later retired to Tomahawk with the whirligig, and after his death, his neighbors donated it to the University of Wisconsin Center in Wausau, where it was exhibited twice before coming to the Art Institute.[3]

Naturalized as an American citizen on May 24, 1945, Memkus could have made the whirligig as a commemorative gesture toward his newly adopted country.[4] As a new American, he might have been inspired by his recent naturalization, in combination with the Allied victory in Europe, to construct this overtly patriotic object. It employs the colors red, white, and blue to highlight the nation's flag, and atop it stands a saluting signalman surrounded by airplane propellers, which, along with the flags, whirl and flutter in the wind.

1. *History of Tomahawk* (publisher unknown, 1970–77), p. 18.

2. Dixie Zastrow, president of the Tomahawk Historical Society, to the Department of American Art, Art Institute of Chicago, Jan. 13, 2011. Files of the Department of American Art, Art Institute of Chicago.

3. Curatorial memo, Jan. 8, 1981. Files of the Department of American Art, Art Institute of Chicago.

4. His naturalization certificate is located in the files of the Department of American Art, Art Institute of Chicago. He was photographed alongside his fellow immigrants as he solemnly took the citizenship oath; the photograph was published in the pages of the *Milwaukee Sentinel*.

SELECTED BIBLIOGRAPHY

Ames, Kenneth L. 1977. *Beyond Necessity: Art in the Folk Tradition*. Exh. cat. Winterthur Museum/Norton.

Barber, Edwin Atlee. 1893. *Pottery and Porcelain of the United States: An Historical Review of American Ceramic Art from the Earliest Times to the Present Day*. G. P. Putnam's Sons.

Bishop, Robert Charles. 1974. *American Folk Sculpture*. E. P. Dutton.

————. 1979. *Folk Painters of America*. E. P. Dutton.

————. 1981. *Gallery of American Weathervanes and Whirligigs*. E. P. Dutton.

Burgin, Martha, and Maureen Holtz. 2009. *Robert Allerton: The Private Man and the Public Gifts*. News-Gazette.

Burks, Jean. 2008. *Shaker Design: Out of This World*. Yale University Press.

Chotner, Deborah. 1992. *American Naive Paintings*. The Collections of the National Gallery of Art. National Gallery of Art/Cambridge University Press.

Christensen, Erwin Ottomar. 1950. *The Index of American Design*. Macmillan.

Clayton, Virginia Tuttle, Elizabeth Stillinger, and Erika Lee Doss. 2002. *Drawing on America's Past: Folk Art, Modernism, and the Index of American Design*. Exh. cat. National Gallery of Art.

Cooper, Wendy A., and Lisa Minardi. 2011. *Paint, Pattern, and People: Furniture of Southeastern Pennsylvania, 1725–1850*. Exh. cat. Winterthur Museum/University of Pennsylvania Press.

Fendelman, Helaine W., and Jonathan Brackett Taylor. 1999. *Tramp Art: A Folk Art Phenomenon*. Stewart, Tabori, and Chang.

Fried, Frederick. 1970. *Artists in Wood: American Carvers of Cigar-Store Indians, Show Figures, and Circus Wagons*. C. N. Potter.

Hollander, Stacy C., with Brooke Davis Anderson. 2001. *American Anthem: Masterworks from the American Folk Art Museum*. Exh. cat. American Folk Art Museum/Harry N. Abrams.

Joyce, Henry, and Sloane Stephens. 2001. *American Folk Art at the Shelburne Museum*. Shelburne Museum.

Kopp, Joel, and Kate Kopp. 1975. *American Hooked and Sewn Rugs: Folk Art Underfoot*. E. P. Dutton.

Lipman, Jean, and Alice Winchester. 1950. *Primitive Painters in America, 1750–1950: An Anthology*. Dodd, Mead.

————. 1974. *The Flowering of American Folk Art, 1776–1876*. Viking Press/Whitney Museum of American Art.

Little, Nina Fletcher. 1984. *Little by Little: Six Decades of Collecting American Decorative Arts*. E. P. Dutton.

Macleod, Dianne Sachko. 2008. *Enchanted Lives, Enchanted Objects: American Women Collectors and the Making of Culture, 1800–1940*. University of California Press/Getty Foundation.

Peck, Amelia, with the assistance of Cynthia V. A. Schaffner. 2007. *American Quilts and Coverlets in the Metropolitan Museum of Art*. Metropolitan Museum of Art/MQ Publications USA.

Priddy, Sumpter T. 2004. *American Fancy: Exuberance in the Arts, 1790–1840*. Chipstone Foundation/D.A.P.

Quimby, Ian M. G., and Scott T. Swank, eds. 1980. *Perspectives on American Folk Art*. Winterthur Museum/Norton.

Ring, Betty. 1993. *Girlhood Embroidery: American Samplers and Pictorial Needlework, 1650–1850*. A. A. Knopf.

Rumford, Beatrix T., and Carolyn J. Weekley. 1989. *Treasures of American Folk Art from the Abby Aldrich Rockefeller Folk Art Center*. Little, Brown/Colonial Williamsburg Foundation.

Seth, Laurel, and Ree Mobley, eds. 2003. *Folk Art Journey: Florence D. Bartlett and the Museum of International Folk Art*. Museum of New Mexico Press.

Swank, Scott T. 1983. *Arts of the Pennsylvania Germans*. Winterthur Museum/Norton.

————. 1999. *Shaker Life, Art, and Architecture: Hands to Work, Hearts to God*. Abbeville Press.

Taylor, Lonn, and Dessa Bokides. 1987. *New Mexican Furniture, 1600–1940: The Origins, Survival, and Revival of Furniture Making in the Hispanic Southwest*. Museum of New Mexico Press Series in Southwestern Culture. Museum of New Mexico Press.

Vlach, John Michael. 1988. *Plain Painters: Making Sense of American Folk Art*. New Directions in American Art. Smithsonian Institution Press.

————. 1991. *By the Work of Their Hands: Studies in Afro-American Folklife*. American Material Culture and Folklife. UMI Research Press.

PHOTOGRAPHY CREDITS

Unless otherwise stated, all images appear by permission of the lenders mentioned in their captions. Every effort has been made to contact and acknowledge copyright holders for all of the reproductions in this publication; additional rights holders are encouraged to contact the Art Institute of Chicago.

Images of objects in the collection of the Art Institute of Chicago were produced by the Department of Imaging, Christopher Gallagher, director. The following credits apply to all images for which separate acknowledgment is due.

P. 10, fig. 1; p. 15, fig. 8: The William H. Miner Agricultural Research Institute; p. 16, fig. 9; p. 17, fig. 11: Courtesy Historic New England; p. 20, fig. 14: Downtown Gallery Records, Archives of American Art, Smithsonian Institution; p. 23, fig. 16: Smith College Archives, Smith College; cat. 8, fig. 2: Courtesy of Pook & Pook; cat. 25, fig. 1: Courtesy of the Smithsonian Institution Libraries, Washington, D.C.; cat. 28, fig. 1: Image courtesy National Gallery of Art, Washington; cat. 29, fig. 2: Courtesy of the University of Michigan Library; cat. 44, fig. 1: Courtesy of the Smithsonian National Museum of American History.

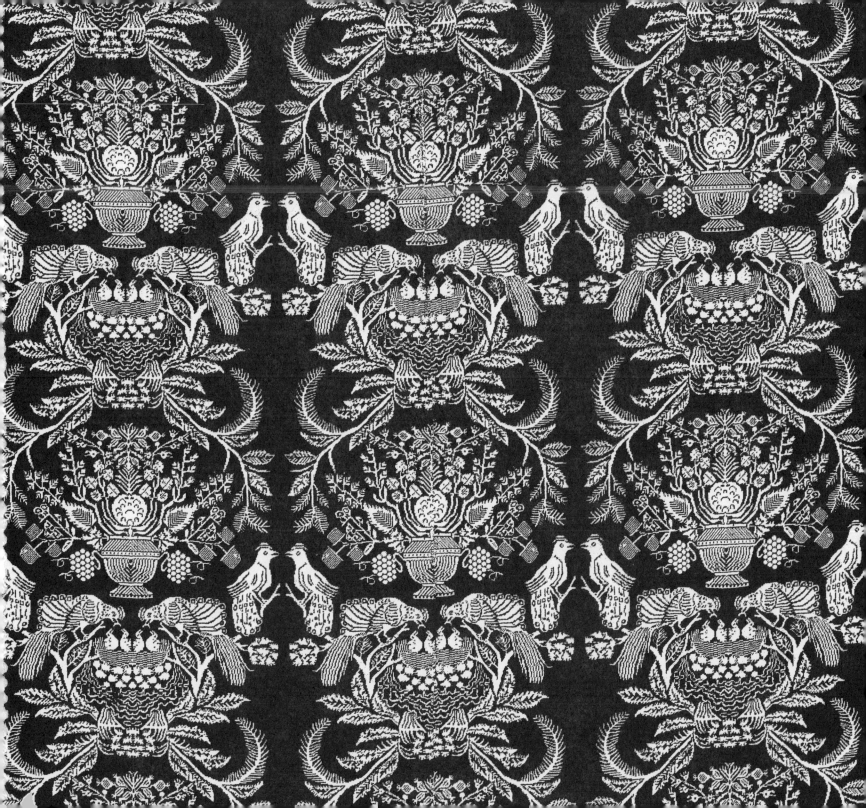